digital 3d design

digital 3d design

SIMON DANAHER

SERIES CONSULTANT
ALASTAIR CAMPBELL

CASSELL&CO

1 TRAD TO CAD 8

2 CORE CONCEPTS 30

3 LESSONS 94

4 WEB 3D 152

5 SHOWCASE 170

6 REFERENCE 182

WORKING IN THREE DIMENSIONS

3D computer graphics are everywhere – in the latest blockbuster movie, TV advertisements, the Web and in magazines. In fact, there is barely any form of visual communication that has not been transformed or improved by digital technology, and 3D graphics lie at the core of the revolution. If you enjoy problem solving, being creative and rewarded for hard work, then you will enjoy working in 3D computer graphics and animation.

What this book aims to do is break down the elements of the 3D thought process and try to explain what 3D is all about – the techniques, the jargon and the tools. This does not necessarily mean that the book is only for beginners – established 3D artists will gain something from it too. Understanding what 3D is all about and exploring its inner working are essential if you are to progress through the early stages to become a 3D digital guru.

If you come from a 2D paint, image editing, layout or Web design background, or have just never used a 3D program before, the world of 3D modelling and animation may seem daunting. Rather than the two dimensions of a flat canvas, your canvas is now space itself, a volume that you have to fill with light, texture, colour and movement.

Actually the design disciplines that apply to 2D work also apply to 3D; it's just the working methods and tools that change. Form, colour, composition and texture are equally important in 3D design as they are in more traditional design practices, and why wouldn't they be?

1

1
The 3D landscape generator Bryce has often been the weapon used to assault our senses. The world doesn't need any more images of crusty terrains and infinite oceans under candy-coloured skies.

2
If you really want to see what not to do, it's worth taking a trip to the Gallerie Abominate at **www.jackals-forge.com**. This particular specimen is a prime example of just how bad it can get.

the GALLERI
ABOMINAT

3
First experiments with Raytracing often look like this image of perfectly reflective chrome balls in a reflective room. A good test for rendering speed, but that's about it.

MOSS ISLEY GOES MENTAL

The upshot of this is that if you are a good designer you will be a good 3D designer. No amount of technique will make up for little talent or lack of aptitude for design. Unfortunately most 3D design work we see, especially that which adorns countless websites across the globe, is often created by the latter category of artist. Bad design is bad design, no matter how you dress it up.

Because most 3D programs, especially the inexpensive ones, make it easy for novices to create 'spectacular' imagery with very little effort or time, this is often the kind of 3D work that people see most frequently. Fantasy landscapes with neon skies and crystal-clear waters, chrome balls, hard shiny objects, flying logos made of shimmering gold are just some of the regular examples of quick and easy design. We've all seen them and probably made them at some point, but these types of images don't do justice to what is really possible with 3D digital art.

8

LEARNING TO SEE • 10

NEW TECHNIQUES • 12

SOFTWARE • 14

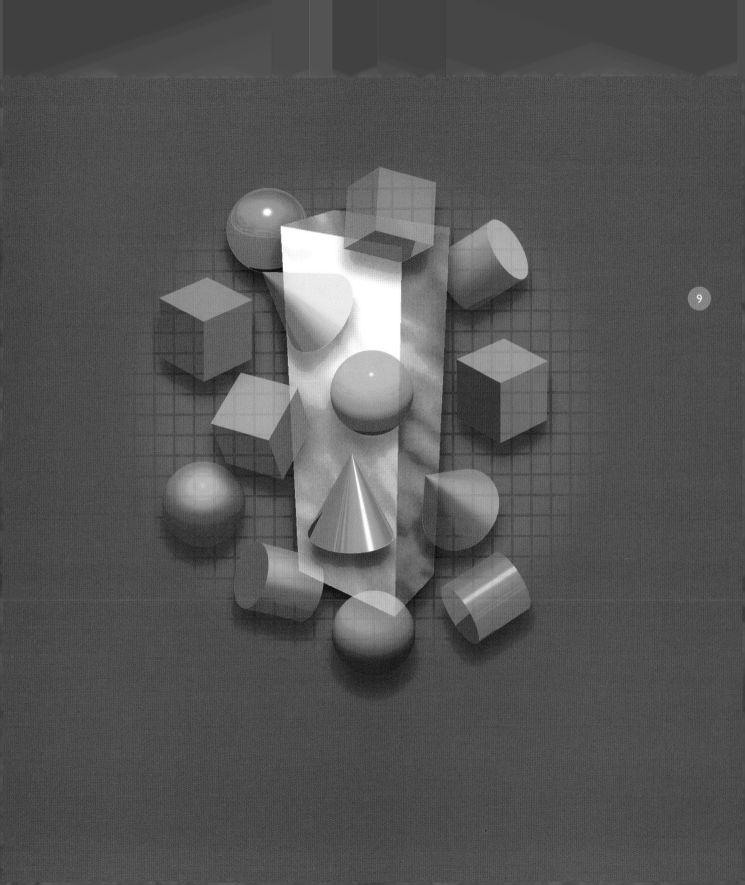

LEARNING TO SEE

Just as a traditional fine artist learns to see rather than merely look, so must the 3D artist. Simple things, such as the properties of everyday materials or the subtleties of human movement and expression, become fascinating subjects of study and examination for the dedicated 3D artist. Every day you will see something new, something that can be added to your understanding of the way things appear or behave.

A direct comparison can be made between the way fine art developed in the last two millennia and the current developments and studies that are occurring in the realm of 3D computer graphics.

Early in the history of painting, perspective was poorly understood and even more poorly reproduced. It wasn't long, however, before artists were able to accurately simulate 3D space and perspective effects, at least sufficiently to create the illusion of depth and space that could fool the eye, even if it was not 100 per cent accurate.

The Presentation of the Virgin (1305) by Giotto shows how early in the history of art perspective was not always well represented.

Leonardo da Vinci's painting of *The Last Supper* (1498) in the Convent of Santa Maria delle Grazie in Milan was used to great effect to simulate an extension of the room in which it was painted. The painting shows a table at which the disciples and Jesus are feasting, but the room in which they are sitting extends backwards with exaggerated perspective, which, though not exactly accurate, works as a visual illusion.

An even greater achievement was made by Michelangelo with his painting of the Sistine Chapel ceiling. An incredibly complex and impressive work, this elevated fresco also demonstrates incredibly subtle 3D touches. What appears at first to be detailed structures in the architecture of the chapel ceiling are, on closer inspection, the work of Michelangelo's hand.

10

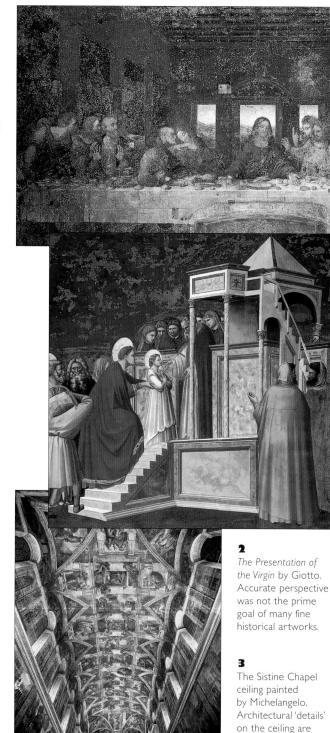

2

2

The Presentation of the Virgin by Giotto. Accurate perspective was not the prime goal of many fine historical artworks.

3

The Sistine Chapel ceiling painted by Michelangelo. Architectural 'details' on the ceiling are actually painted by the artist.

3

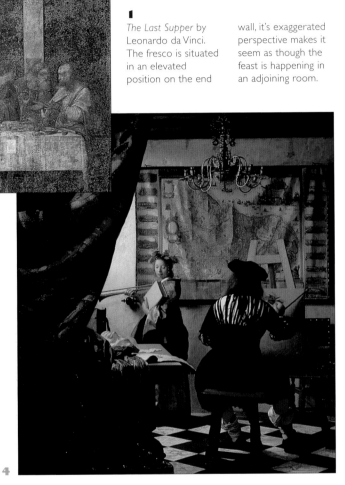

1
The Last Supper by
Leonardo da Vinci.
The fresco is situated
in an elevated
position on the end
wall, it's exaggerated
perspective makes it
seem as though the
feast is happening in
an adjoining room.

The understanding and rendering of the effects of
light by later painters, such as Van Eyck, Canaletto
and Vermeer, are incredible. Vermeer in particular
painted simple pictures where the event or subject
depicted was of secondary importance. Composition,
light and form were the prime focuses in these
seminal works of art.

What has this brief departure into the history of
painting got to do with 3D graphics I hear you ask?
The accurate description of the effects of light is of
just as much importance to the 3D artist seeking realism
as it was to the painters described above. A good
3D artist is able to push his or her tools to the limit in
order to produce beautifully lit and rendered 3D scenes.
A push-button solution to the production of credible
computer imagery does not yet exist. Thankfully, we
have talented 3D artists instead.

5

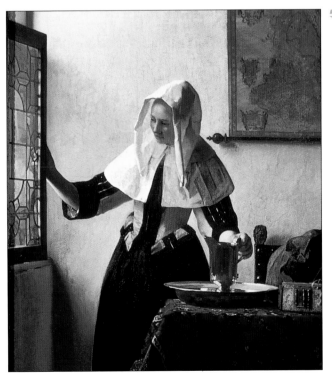

4

4 | 5
These two paintings,
The Art of Painting and
*Young Woman with a
Water Jug* by Vermeer,
both demonstrate
wonderful attention to
detail with respect to
the light in the scenes.

NEW TECHNIQUES

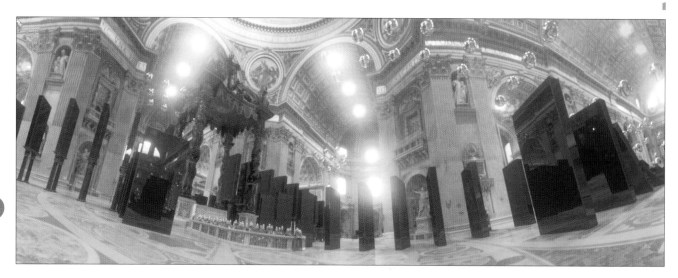

One of the great advances made in the world of computer imagery has been accomplished by Paul Debevec at the University of Southern California's Institute for Creative Technologies. Debevec's approach to creating truly realistic rendering is first to accurately capture the huge dynamic range that is experienced by the human eye.

Photography produces believable imagery by its very design. It records an image of the real world using a similar lens system to that of the human eye, and with similar limitations and artefacts (such as glare, blur, etc.). Where the photographic system falls down is in capturing and reproducing the dynamic range that the eye experiences.

Dynamic range is the measure of the range of brightness values that a given system can record. The human eye can detect massive variations in brightness values, for example. We don't need to change our retinas for more sensitive ones in low-light conditions, as our eyes and brains can adapt (though this may take a few seconds or minutes in extremely low light). However, the film in a camera can't always cope with such a wide range of intensities.

1 | 2 | 3
By accurately capturing the light in a real environment (in this case St Peter's Basilica, Rome) using variable-level, multiple-exposure photography an image can be created to 'light' a 3D scene reproducing that environment. These images are created using the high-dynamic-range imagery lighting technique by Paul Debevec. His film *Fiat Lux* depicts these dark monoliths falling like dominos inside St Peter's Basilica. The monoliths are 3D models, as is the backdrop of St Peter's, except that it has been created using photos of the real building. The lighting illuminating the 3D scene is from St Peter's too, so it all looks very natural.

2

3

What Debevec's research has shown is that, by using multiple photographs of an environment that have employed a wide range of different exposure levels, it is possible to capture an image with a much wider dynamic range. The sequence of photos is scanned into a computer and the brightness values gathered into a single image that contains the entire dynamic range captured across the multiple exposures.

While a computer display cannot present this image in a greater range of brightnesses than its monitor can display, the image can be used for different purposes, such as lighting a 3D scene. By recording an environment using this high-dynamic-range technique, it can then be used in a 3D program that supports this special image format to accurately re-create the lighting of the original environment. Not only the intensity but the colour and direction of the light are re-created. The end result is arguably the most realistic computer imagery that has ever been produced. You can sample some of Paul Debevec's work at **www.debevec.org.**

13

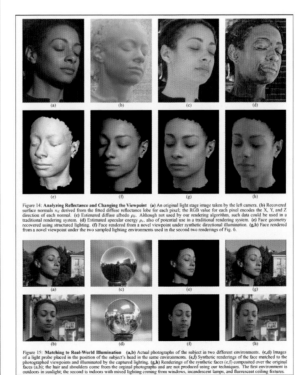

Figure 14: **Analyzing Reflectance and Changing the Viewpoint** (a) An original light stage image taken by the left camera. (b) Recovered surface normals n_d derived from the fitted diffuse reflectance lobe for each pixel; the RGB value for each pixel encodes the X, Y, and Z direction of each normal. (c) Estimated diffuse albedo ρ_d. Although not used by our rendering algorithm, such data could be used in a traditional rendering system. (d) Estimated specular energy ρ_s, also of potential use in a traditional rendering system. (e) Face geometry recovered using structured lighting. (f) Face rendered from a novel viewpoint under synthetic directional illumination. (g,h) Face rendered from a novel viewpoint under the two sampled lighting environments used in the second two renderings of Fig. 6.

Figure 15: **Matching to Real-World Illumination** (a,b) Actual photographs of the subject in two different environments. (c,d) Images of a light probe placed in the position of the subject's head in the same environments. (e,f) Synthetic renderings of the face matched to the photographed viewpoints and illuminated by the captured lighting. (g,h) Renderings of the synthetic faces (e,f) composited over the original faces (a,b); the hair and shoulders come from the original photographs and are not produced using our techniques. The first environment is outdoors in sunlight; the second is indoors with mixed lighting coming from windows, incandescent lamps, and fluorescent ceiling fixtures.

4

Another project by Paul Debevec involves capturing the 'reflectance field' of a human face. The images you see here are from a computer model of an actress, which is being rendered using different high-dynamic-range image environments.

SOFTWARE

The most important tool a 3D artist has (aside from a desire to create, and his or her own inventiveness and skill) is 3D software. What follows is a brief compendium of some of the most popular 3D programs that are available today.

Maya

Maya was developed by Alias|Wavefront as the 3D application to end all 3D applications, at least as far as character animation and effects are concerned. It is considered by many to be the holy grail of 3D animation, and because of its sheer power and flexibility it has become a firm favourite throughout the 3D graphics industry. From film effects to product visualization, fine art and games, Maya is fast becoming the standard by which all others are judged.

Maya's core operating strategy is based on nodes. Everything in Maya is a node with an input and an output, so that you can connect various nodes together to create custom events and effects. Maya also features powerful technology, including built-in dynamics simulation, fur and cloth simulation and an impressive set of modelling tools.

Maya is available on SGI IRIX, Windows NT/2000, Linux and Mac OS X.

2

1

1
Maya is the *de facto* standard in high-end 3D animation. Like Photoshop it has become the program by which all others are judged.

1

14

Photorealistic RenderMan

Photorealistic RenderMan is the rendering program created and used by Pixar to make the fantastic images we've seen in films such as *Toy Story* and *Jurassic Park*. It has become a rendering standard used in the film industry because of its exceptional quality. Because of its wide acceptance, many other programs can link to it, effectively replacing their built-in rendering engines.

Based on a technology called REYES (Renders Everything You Ever Saw), Photorealistic RenderMan, or PRMan as it is known for short, fulfilled the two main criteria required for 3D graphics to be used effectively for film production. Firstly it was fast, and secondly it could simulate the motion-blurring effect of a motion picture camera, thus making it possible to integrate 3D-rendered imagery with live-action footage.

PRMan is available for Windows NT, SGI IRIX, Sun SPARC and Linux.

15

2
Though Maya was used for plenty of the effects and animation in the film *The Mummy*, much of the rendering was done with Pixar's Photorealistic RenderMan software.

3
A classic image from Photorealistic RenderMan. Though the PRMan standard supports all kinds of rendering methods, PRMan does not use raytracing. Many raytracing effects, such as reflections, can be easily 'faked' using clever workarounds.

4
Photorealistic RenderMan creates images using the REYES rendering alogorithm (Renders Everything You Ever Saw) and supports high-quality displacement mapping.

Softimage 3D and Softimage XSI

Softimage 3D was one of the first 3D animation packages designed with artists in mind. Before its release, most 3D software was proprietary and developed by enthusiasts, researchers or professionals working in the film industry. Most of the software required a degree in programming or mathematics to use it, so it was difficult for traditional 3D stop-motion animators to operate. Softimage 3D provided ease of use, so that talented animators could be put to work creating digital 3D animation.

Many of the characters that you see in films are still created using Softimage 3D, though in recent times Maya has slowly taken over in this department. Softimage has recently released their next-generation 3D product, XSI, which incorporates many new and advanced features, including Mental Image's Mental Ray rendering engine.

Softimage is available for use on SGI IRIX, Windows NT and Linux.

Lightwave 3D

Lightwave 3D is actually made up of two programs – Modeler, which handles the building and texturing of 3D objects, and Layout, which is where you animate and render them. It has become a popular choice for 3D artists working in film, broadcast and games, because of its high-quality rendering and comprehensive toolset.

2
XSI uses Mental Ray for its rendering. Mental Ray is a very high-quality renderer and capable of stunning results.

1
This old man was created in XSI and is a prime example of just how good the results from the program can be.

The Pick of the Month is the ultra-photorealistic work of Ulf Lundgren, a Modeler and Texture Artist working with Filmtecknarna in Sweden.

1

3

Originally developed on the Amiga platform, Lightwave 3D was designed to provide 3D effects for video production. It has since blossomed into a fully fledged 3D animation system that is capable of advanced modelling and animation with excellent rendering quality.

Lightwave was one of the first commercial packages to provide subdivision surface modelling in the form of MetaNURBS technology (*see pages 56–57*). Though the concept of Subdivision Surfaces had been around for a while, Lightwave's MetaNURBS let artists build organic-looking single-skin models with relative ease. Similar systems are now available in most popular 3D programs.

One of the main reasons for the program's popularity is that, from the outset, the program has had an extendable architecture, meaning that third-party developers can write plug-ins that extend Lightwave's functionality. There is also a large number of free and shareware plug-ins available, so an artist can easily expand the toolset without having to part with a great deal of extra money.

Lightwave is currently available for Windows, IRIX, Sun Solaris and Macintosh computers, including OS X.

17

4
Lightwave 3D is used in film, broadcast, games and multi-media. Rendering quality is very high and the program features excellent organic modelling in the form of MetaNURBS.

3
Lightwave has been a popular choice for producing 3D animations and effects for SciFi TV series, including *Babylon 5* and *Star Trek: The Next Generation*.

Cinema 4D XL

Like Lightwave, Cinema 4D began life on the Amiga, before migrating to the PC and Macintosh platforms. The current version, dubbed XL, features impressive modelling and animation tools coupled with one of the fastest raytrace rendering engines available. XL is one of the few programs at its price point that has relational modelling capabilities in the form of a proprietary hierarchical modelling system. Subdivision Surfaces are supported and there are also tools for character animation.

Maxon produces new versions of the software at a fast rate, rivalling Alias and Maya in this respect. In the fast-paced world of 3D technology this is a feature not to be underestimated, as technology becomes rapidly outdated. Cinema 4D is also expandable via plug-ins – there are not quite as many available as for Lightwave, but many are free. The latest version features a new anti-aliasing system, fast radiosity and caustics rendering, and workflow tools such as multi-pass rendering output.

Cinema 4D XL is available for use on Macintosh and Windows PCs.

1
Cinema 4D XL has become increasingly popular thanks to the fast development pace provided by its developers, Maxon. Maxon was also one of the first companies to express their commitment to develop for Mac OS X.

2
Like Lightwave, Cinema 4D XL is well suited to broadcast work, character design and print graphics. The program is also very fast at rendering.

3
Cinema 4D XL can be used to create realistic or stylized artwork. The modelling system features a hierarchical pipeline that keeps the modelling process 'live' and accessible.

4
ElectricImage is particularly good at rendering very large scenes containing millions of polygons. The rendering is very high quality and fast.

5
The latest version of ElectricImage (called ElectricImage Universe) has much better support for this complex area of 3D animation.

19

ElectricImage

Used on films such as *Terminator 2* and *Star Wars Episode I: the Phantom Menace,* ElectricImage is one of the best 3D animation systems. It features exceptional quality rendering that can rival PRMan, and is also the fastest renderer available today.

Until recently the program was limited to rendering and animation. If you wanted to model you had to use another 3D program, usually AutoDesSys' Form•Z, at the time an animationless modelling and rendering program. The latest version of ElectricImage comes with its own separate modelling program based on Spatial Technology's ACIS geometry kernel and offers a high-precision solid- and surface-modelling environment. The very latest version of ElectricImage, dubbed EI Universe, adds raytracing (*see page 88*) to its rendering capabilities and many more modelling features. Subdivision surface modelling is on offer too in the form of UberNURBS, a similar system to Lightwave's MetaNURBS system.

ElectricImage is available for Macintosh, Windows PCs and Sun Solaris workstations.

mental images

"WALKING WITH DINOSAU
Directed by Tim Haines
© BBC SCIENCE / DISCOV
Computer Animation and Sp
Visual Effects by FrameStor
Images rendered with menta

3D Studio Max

3D Studio Max is one of the most popular 3D programs. Discreet, the developers, would have us believe that it is the best-selling 3D animation package, though this may not be the whole truth. The company has an aggressive education licensing policy and Max is the program that many budding 3D artists learn on in education establishments. It's often believed, usually by newcomers to 3D, that Max is the be all and end all of 3D graphics, but, while it is competent, this is certainly not the case.

Max was a development of 3D Studio, the DOS program that had become a popular choice for 3D animation on the desktop. It was completely rewritten for Windows NT to take advantage of the more advanced operating system. Recently Discreet has tempered criticism of its rendering quality by making Mental Ray available as a plug-in renderer at extra cost. Like Lightwave, Max is buoyed by a large third-party developer community and can boast a vast number of free and shareware plug-ins.

3D Studio Max is available for Windows NT and 2000.

Sony goes on a WildTangent
with 3ds max for A Knight's Tale

1
Mental Ray is a high-quality rendering system and competes with RenderMan in the high-end world of 3D rendering. It supports technology such as radiosity and caustics.

2
Mental Ray has been used in many films, notably in *Fight Club*. There are many shots in this film that are totally 3D-generated.

3
Max has a modular design and the basic package has IK and character tools, but for advanced character work you'll need to buy the Character Studio plug-in.

4
3D Studio Max has long been a favourite for game production, but recently it has lost ground to competing packages.

20

4

5

Lightscape is dedicated to radiosity rendering. Radiosity calculates the indirect illumination in a scene and is capable of stunning realism.

2

5

ional, 1999
ects by
 ray.

6

Mental Ray

Mental Ray is a raytrace renderer made by Mental Images GmbH. This program features a sophisticated shading language and has been used most famously in tandem with Softimage 3D and XSI.

Mental Ray is an application that features exceptionally high rendering quality and supports a vast array of effects, such as the simulation of natural light phenomena through radiosity and caustics.

Mental Ray is available to use with 3D programs running on Windows PCs and Silicon Graphics IRIX workstations.

21

Lightscape

Lightscape is another rendering application, but one that focuses primarily on radiosity. This application is often used by companies creating architectural visualizations because of the extremely accurate way it handles the subtleties of lighting. This is important because it allows architects to get an accurate picture of the way a building reacts to real lighting conditions. Simulations can be performed for both artificial and natural lighting, and sun studies can be performed that will indicate how the spaces in the building will look at different times of the year.

Lightscape is available for use on Windows PCs.

6

Lightscape has no modelling tools of its own. You must model elsewhere and import the scene for texturing, lighting and final rendering.

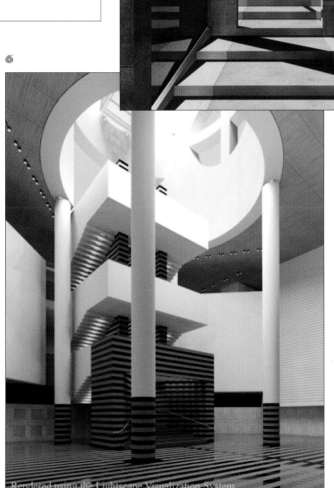

Rendered using the Lightscape Visualization System

POVray

POVray (Persistence Of Vision RAYTRACER) is a rendering application that generates raytraced rendering of the scenes with which you supply it. It's a command line renderer, so has no graphical user interface as such, and is therefore popular with pros as well as enthusiasts and hobbyists.

POVray is available for MS DOS, Windows 95/NT, Macintosh, Linux, Sun OS, Unix and Amiga.

TrueSpace

TrueSpace is another 3D program with a long history. Recently the company that developed the program, Caligari, has introduced novel features that take advantage of the powerful graphics capabilities in today's desktop computers. The entire interface can be displayed as a 3D scene, with tools and features rendered using OpenGL or Direct 3D in real-time.

The program features animation and modelling tools as well as raytrace rendering, complete with hybrid radiosity.

TrueSpace is available for Windows PCs.

Rhino

Robert McNeel and Associates' Rhino is an industrial-strength 3D-modelling program that harnesses the power and flexibility of NURBS modelling to great effect. The Rhino 3D-modelling program is mainly a modelling program with basic rendering for visualizing the objects that you create, though there are indications that a high-quality rendering engine will be included in later versions.

Rhino is available for use on Windows PCs.

1
POVray is a popular freeware rendering program that supports raytrace and radiosity rendering and is available on most platforms.

2
TrueSpace is a mid-range 3D animation program that has a good set of features including NURBS modelling and radiosity rendering. Image quality is high considering the price.

Bryce

Bryce whipped up a storm of enthusiasm when it was first introduced, and it still has legions of devoted users. It's primarily a landscape and environment generator that can be used to create all sorts of realistic and fantasy scenarios with the bare minimum of user input. Should you want to get deeper into the creation of Bryce images, it offers more sophisticated tools too.

Bryce was a groundbreaking 3D program in many ways, not least because of its love-it-or-loathe-it interface, which has candy buttons and hidden features. Based on a raytracing renderer, Bryce allows you to create simple animations and high-resolution stills. The modelling is not as comprehensive as it is in other 3D applications, because it was never intended to be an all-round 3D program. Most of the modelling in Bryce can be done using primitive objects and Boolean rendering, though the Terrain Editor is a tool that allows you to sculpt landscapes using a simple greyscale-to-height mapping scheme.

Bryce is available for use on both Macintosh and Windows PCs.

23

3

4

Bryce is a landscape generator that can be used to create all manner of 3D worlds. You can also create basic objects and import 3D models.

Bryce tends to be a 'one click art' type of program. The rendering quality is average but it is capable of very good output with some effort.

3

Rhino is an industrial-strength NURBS modelling system with basic rendering, decent OpenGL support and comprehensive tools.

4

Poser

From the same stable as Bryce, Poser broke similar new ground as the first commercial 3D program that could be used to create procedural human figures. Poser people are now ubiquitous in 3D graphics and are highly recognizable, but the program has numerous quality features, such as a procedural walk generator, motion output (so that you can create animations in Poser and apply them to different models in another 3D program), lip syncing and animation.

You can also import 'props', other 3D objects created elsewhere, which Poser figures will hold, wear or interact with.

Original developers MetaCreations (now Viewpoint) sold Poser when it shed its graphics division to concentrate on Web 3D development, but thankfully it was bought by a company comprising the original MetaCreations development team. Called Curious Labs, the company is continuing the development of this popular 3D program.

Poser is available for use on Macintosh and Windows PCs.

24

1

1
Poser is a dedicated figure-designing system. It can be used to create 3D human characters using a library of preset humans, which can be modified extensively. It can be used for animation too, and features IK and a good timeline. Rendering quality is average but images can be easily touched up.

2
Strata has a very good raytrace renderer, which, in the Pro version, includes radiosity.

3
There are three versions of Strata 3D: a free version with fewer features, a paid-for *plus* version with extra features and a full version, *pro*, which is like the free version but with extra plug-ins.

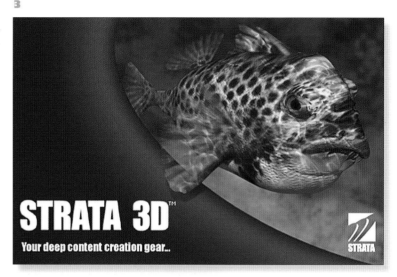

Strata 3D

An old favourite, Strata 3D features a good selection of tools for what is now a relatively low-end product, at least in terms of price. The *base* version is available free of charge, while extra features are available in the paid for version, *plus*.

The full version, *pro*, features raytracing and radiosity rendering, as well as animation and effects. Strata 3D is available for Windows and Macintosh.

Pixels 3D

Based on NURBS modelling, Pixels 3D is an accomplished 3D system for the Macintosh. It features a workstation-like interface that is reminiscent of high-end offerings such as the original Softimage 3D. It also has a good-quality raytrace renderer.

Interestingly the company is currently developing a rendering system called Tempest, a program which is closely based on Pixar's PRMan and can be used to render across networks with great versatility.

Pixels 3D is available for the Macintosh only.

4
The animation tools in Pixels are very good. There are IK, some clever render-based NURBS-blending features, scripting and other high-end tools.

Pixels 3D is a Mac-only 3D animation program. It's based on NURBS and has a lot of very powerful features, yet it doesn't cost the earth.

25

Hash Inc. – Martin Hash Animation Master

Hash Animation Master is a deeply satisfying animation program to use. Not only does it make 3D character animation relatively straightforward, but it also does so for very little money – about as much money as a decent Max plug-in in fact.

Its IK and joints system are fantastically designed and put many more expensive 3D programs to shame. The geometry is based on proprietary Hash Patches, well suited to character animation work.

Animation Master is available for Macintosh and Windows PCs.

ElectricImage Inc. – Amorphium

Amorphium is ElectricImage's other 3D package. It is based on a 3D-sculpting theme, so you can take simple primitive objects and mould them like putty into almost any shape that you want. It does this using OpenGL display and a hoard of tools, ranging from displacing brushes to deforming modifiers (bend, twist, bulge, etc.).

The program also offers radiosity rendering and raytracing and has Flash output for a quick and painless way to get pseudo-3D animations onto the Web.

Amorphium is available for Macintosh and Windows PCs.

Avalanche Software

1

2

1
Animation Master is a well thought-out and inexpensive program that is exceptional in some areas (notably character animation).

2
Amorphium allows you to mould and sculpt objects, then texture and render them using radiosity.

4
ImageModeler can
be used to create
3D models from
photographs.

5
ImageModeler
requires little set-up
or information about
the camera system
used, and can re-
create literally any
kind of shape.

6
ImageModeler is
particularly useful for
creating 3D objects
for the Web, but is
also used for feature
films and effects work.

3
Using Amorphium
you can push, pull,
twirl and twist basic
forms into any shape
you can imagine.

RealVIZ – ImageModeler

Developed by RealVIZ, ImageModeler is one of the most intriguing 3D products that has come along in recent times. Rather than working from scratch, building up a model of a 3D object using polygons or NURBS, a lot of special tools and even more patience, RealVIZ suggests that you should use a photograph. It sounds too good to be true, or even possible, yet this is exactly what ImageModeler achieves.

By taking a series of photographs of the object to be modelled from different angles, together with a reference target, ImageModeler can reconstruct the object in 3D to a high degree of accuracy.

The user simply marks out the same points on the target (a simple grid of points), which is of a known shape, in each photograph and ImageModeler uses this as a calibration guide. You then do exactly the same for the object, marking the details in each picture. Eventually, when enough samples have been taken, the software does some nifty calculations and builds a polygon mesh that does indeed represent the object. The software also extracts textures from the photograph and applies them to the model.

The advantages of this the RealVIZ Image Modeler are obvious, since almost any shape object can be reconstructed. However, the downside of it is that the object must exist in the first place. It does of course allow unique 3D models that are made out of clay to be 'digitized' using this photographic technique.

ImageModeler is available for use on Windows PCs and Mac OS X.

27

Kaydara – FilmBox

FilmBox has captured a bit of a niche because it is one of the few 3D systems that is solely geared towards real-time animation and motion capture. Motion capture is a technique whereby an actor's movements are recorded in three dimensions as they perform. This captured motion can then be applied using some sophisticated digital rigging to animate a full 3D character.

FilmBox features impressive tools for managing complex animations, merging captured data with keyframe animation and reducing motion capture data to a manageable number of keyframes.

FilmBox is available for Windows PCs and Mac OS X.

1
FilmBox is a motion-capture and keyframe animation program used for real-time broadcast (e.g. TV presenters and virtual actors) and for managing motion-capture data and applying it to 3D models.

2

SolidThinking

A robust NURBS modeller and high-quality raytrace renderer, SolidThinking features polygon and subdivision surface modelling, construction history and special analytic tools useful for product visualization and CAD. Rendering is supplied by a high-quality raytracer and there is also radiosity. SolidThinking can be used as a front end to BMRT and Photorealistic Renderman.

SolidThinking is available for Windows and Macintosh.

2
FilmBox can record motion capture data from many different capture devices and apply it to 3D models.

28

3
This image was created using BMRT, a shareware rendering program created by Larry Gritz at Pixar. The program features raytracing and radiosity and has been used in many feature films.

4
SolidThinking is a powerful NURBS modeller that also has good polygons and subdivision surfaces tools. Rendering is very good and the program can link to BMRT and Photorealistic RenderMan for rendering too.

Blue Moon Rendering Tools

BMRT, or Blue Moon Rendering Tools, is the work of Larry Gritz, who is currently working at the world-famous Pixar animation studios. BMRT is a Renderman-compliant command line renderer that boasts complete compatibility with Pixar's Renderman RIB interface, which is the standard for the communication of scene files from modelling applications to renderers.

Unlike Photorealistic Renderman, BMRT features raytracing and radiosity and has been used to render elements in Pixar features in situations where accurate reflections precluded the use of PRMan (notably in Pixar's feature film *A Bug's Life*). It is also a shareware product and can be used for a very small sum.

BMRT is available for Windows, Linux, SGI IRIX and Sun Solaris.

3D COMPUTER GRAPHICS • 32

ANATOMY OF 3D SPACE • 36

VIEWS INTO THE 3D WORLD • 38

JOINING THE DOTS • 40

TRANSFORMATION • 42

MODELLING • 44

HIGH-LEVEL TOOLS • 46

CURVES, SPLINES AND RESOLUTION • 48

RESOLUTION • 50

SPLINE PATCHES • 52

BÉZIER SPLINES AND SURFACES • 54

NURBS • 56

SUBDIVISION SURFACES • 58

GEOMETRY USES • 62

SHADING • 64

ILLUMINATION • 72

SPECULARITY • 74

USING IMAGE MAPS • 76

CONTROLLING MATERIAL CHANNEL INTENSITY • 80

BUMPS VERSUS DISPLACEMENT • 82

ENVIRONMENT MAPPING • 84

RENDERING • 86

RAYTRACING • 88

SCANLINE RENDERING • 90

RADIOSITY • 92

3D COMPUTER GRAPHICS 1

We live in four dimensions – three spatial dimensions and one temporal dimension. With stereoscopic vision we can perceive depth and distance and our brain is also capable of discerning minute differences in shade, texture and movement. This makes replicating the real world a bit tricky and explains why 3D graphics can be very frustrating but, thankfully, highly rewarding too. In this chapter we hope to introduce, as gently as possible, some of the core concepts in 3D graphics, as well as to provide a brief overview of the key technologies that are involved when creating 3D imagery on a computer.

It could be argued that 3D graphics are mainly used to reproduce the real world for the entertainment industry, but that's just a portion of its many and varied uses. 3D graphics can just as easily be found being used to create totally unreal images, and is also used in medical research and diagnostics, training and visualization. The important thing to remember is that 3D graphics programs produce 2D images, regardless of how these images are put to use. It doesn't matter how

2

A new 3D image display box at an unveiling in Tokyo. This is the world's first 3D image display visible to the naked eye.

1

3D graphics as used in the feature film *Toy Story 2*. Produced by Pixar and Disney. *Toy Story* was the first ever full-length completely 3D animated film ever produced.

3

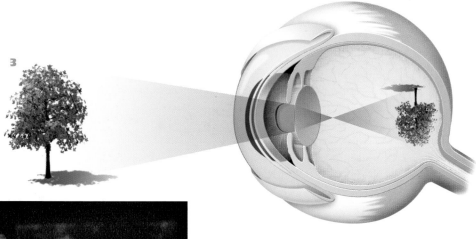

3
This is how we perceive the world visually, by means of 2D images projected onto our retinas. It is only because we have two forward-pointing eyes that we can perceive depth and '3D-ness' in the real world.

4

the images are presented to a viewer, be they pre-rendered and read back in a movie file on a computer or printed onto celluloid and projected on the big screen: the end result is just a two-dimensional image. Likewise with interactive 3D applications such as computer games, Web 3D or virtual reality systems, the output is still a two-dimensional image, albeit blitzed to the screen in real-time rather than saved out to disk.

4
On the 'holo deck' in *Star Trek: Next Generation* – the background is a hologram.

3D COMPUTER GRAPHICS 2

Stereoscopic VR systems that simultaneously display a pair of 2D images to each eye individually fool the brain into thinking it's seeing 3D, but even this is still far from the real thing. As far as we know there are no holographic display systems commercially available, though there is undoubtedly someone working on the problem at the time of writing. To be fair, the 3D world we live in is itself an illusion because the 3D-ness we experience is due to our brain interpreting two slightly different 2D images that are projected onto our retinas.

In the world of CAD and industrial design, 3D computer programs can be used to create actual 3D objects, and this is about the only way that 3D objects can be created directly by a computer. By sending the 3D description of an object to a computerized lathe, drill or, even better, stereolithography machine, the digital data is then converted into a real, functioning 3D object. With stereolithography a laser penetrates a vat full of a photopolymer, a special chemical substance that solidifies when struck by light of a particular wavelength and intensity (for example, by a laser). Using the digital 3D data the laser is able to trace the volume of the object in the vat in order to re-create the 3D form. Unfortunately the output is limited by the laws of physics – laws that are routinely broken in the world of 3D graphics.

1
The end result of a stereolithography session is removed from the machine once the unsolidified photopolymer has been drained away.

2
Stereolithography output creates real objects by guiding laser light through a vat of a special photosensitive polymer, which solidifies when laser light of the right type and intensity strikes it. By guiding the laser beams through the vat, a 3D object is formed.

3
A variety of objects can be created, and this rapid-prototyping is very useful in the world of engineering and product design, since a prototype 3D model can be created in a fraction of the time it would take to machine it.

2

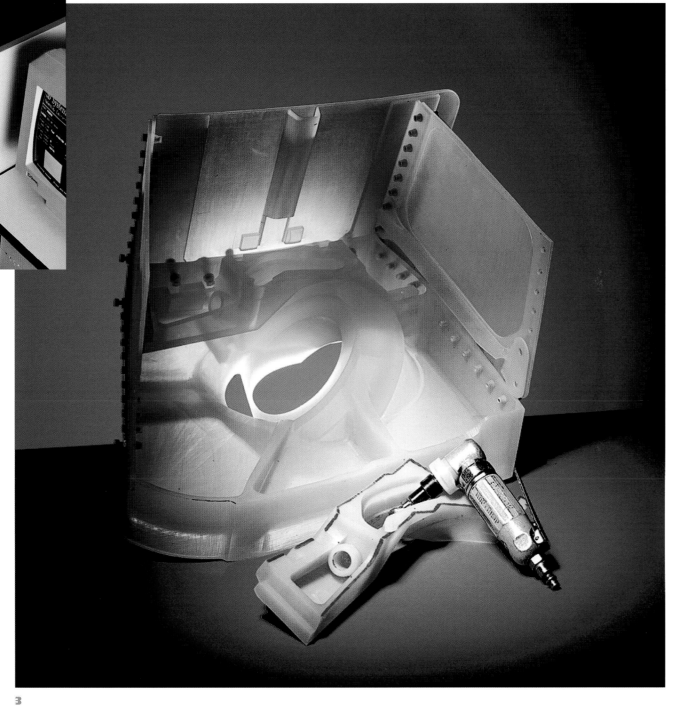

ANATOMY OF 3D SPACE

3D space is the computer software's internal representation of three-dimensional space, and is a very close approximation of the space we live in. By defining three directions – x, y and z – perpendicular to each other, we can plot the location of any point in this artificial 3D space using a measurement along each of the three directions. This space is also known as Cartesian coordinate space, and was named after the French philosopher and mathematician René Descartes. Don't worry, though, you don't need to be a maths graduate to understand or use Cartesian coordinates.

Where the three axes meet is the centre of the computer's 3D space, which is also known as the origin. In Cartesian coordinates this has x, y and z values of 0 and is written 0,0,0. Therefore, if you wanted to plot a point 2 units in y, 3 units in x, and 1 in z this would be written as 2,3,1 in Cartesian coordinates.

A difficulty arises when transposing ideas into a synthetic 3D space because a 3D artist interacts with the software on a computer using a 2D device, either a mouse or stylus, and the feedback on the computer screen is also in 2D. Somewhere in between, existing

1
The three directions, x, y and z, are all that is required to define 3D space on a computer. Traditionally these three axes are also coloured for ease of identification: x is red, y is green and z is blue, and this is true for the majority of 3D programs. There may be one or two shareware applications that don't adhere to this convention, but all the major programs do.

2 | 3 | 4
Cyber gloves let you interact with 3D graphic images just as if they were real. We have yet to see these sorts of 3D systems make any real impact on our lives, though Hollywood got plenty of mileage from the concept.

36

only in computer code, does the digital 3D world really exist. This can pose a problem, because it's just as easy to point your cursor at the front of an object as at its back using these 2D devices – the computer has no way of knowing which side you're interested in without some clever calculating by the software and some concentration by the artist.

This problem can be one of the most disconcerting aspects of 3D graphics, especially for beginners. There are many ways in which this particular barrier has been overcome by software companies and artists over the years. For example, cyber gloves and 3D goggles or two-handed input devices can be used. However, after a short time, a good 3D artist adapts and learns techniques that enable him or her to interact with the software transparently without the need to use these sophisticated gadgets.

4

3

VIEWS INTO THE 3D WORLD

The 3D world that you work in on your computer can be displayed in a variety of ways. The most obvious is a single 3D view, which displays a floor grid and x, y and z axes so that you can orient yourself in the virtual world. A virtual camera displays the view, complete with perspective, so that you can easily navigate the scene and get a feel for the 3D space. Moving the 3D view is very important because the subsequent parallax effects provide the brain with visual cues so that it can figure out where objects are in the scene. Near objects will move across the screen more rapidly than distant objects, thus exposing their true location. You can observe the parallax effect if you hold up one finger at arm's length and the other about

a foot away from your nose and line them up. As you move your head from side to side the near finger will appear to move from left to right with respect to the distant finger.

Another type of view is the orthogonal view. This is a parallel 2D view, very similar to a plan of a building, and it is usually perpendicular to one of the three Cartesian axes. There are six orthogonal views, and these are often named top, left, front, back, right and bottom. Objects that are the same shape and size appear identical in an orthogonal view, no matter how far away from each other they are. Orthogonal views are therefore useful to align objects. The other useful thing about them is that they allow you to move objects

From this view it's not clear exactly how big the sphere is, or where it is in relation to the other two objects.

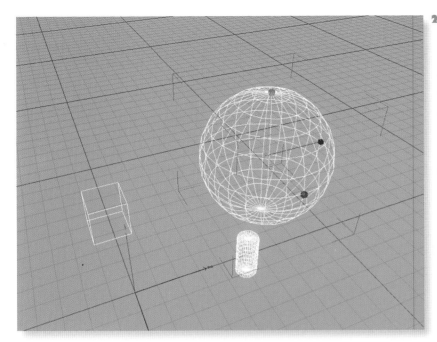

that are constrained to the view plane. You can do this in the perspective view too, but you would have to tell the software that you wanted to move the object in x and z but not y, which would take a few extra mouse clicks. It's far easier just to drag the object in the Top view (since this is perpendicular to the xy plane).

Please note that throughout this book we will assume y to represent the Up axis of the 3D world. (Some 3D programs use y as the Up axis, while others take z to be Up.)

39

2
Moving the view discloses that the sphere is in fact large and distant in the scene. You'll find that as you are working on complex models, rotating the view constantly as you examine the object will give you a much better idea of its form.

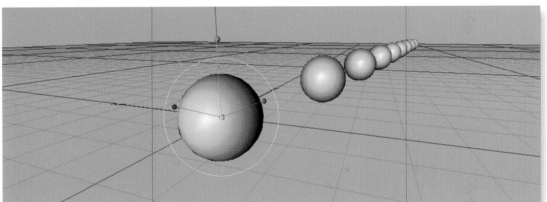

3 | 4
Similar objects viewed in an orthogonal view appear the same size regardless of their location in 3D space.

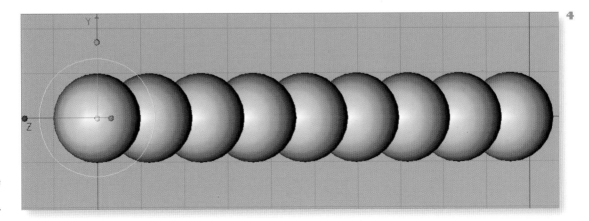

JOINING THE DOTS

O nce we have 3D space we can build 3D objects, but how do 3D programs create objects? What are they constructed from? As we've seen previously, any point in space can be defined using a set of three coordinates. Imagine these three points all lying in the same plane (but not overlapping) and imagine drawing a line from one to the next, then to the next and back to complete a triangle. If we tell the computer to fill in such a triangle, we have the simplest building block in 3D graphics, the three-point polygon. The triangle is the simplest 3D structure that can be filled in or rendered by 3D software so that it looks solid. Actually, a triangle could be thought of as a 2D object because it cannot be bent or twisted into a third spatial dimension. Triangles therefore have a special place in 3D graphics.

40

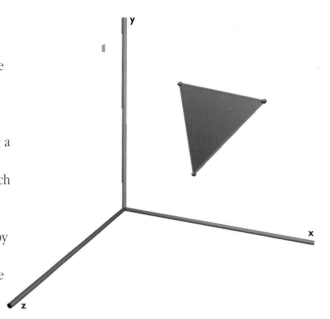

1
Three points that lie in the same plane (xy) are joined together with edges to make a triangle. The enclosed area is filled in to form a face that can be rendered.

2
Now, add three more triangles and join them together so they are enclosing a volume, but let them share the points and edges where they meet. This forms the simplest 3D volume – the tetrahedron. Polygons can have any number of sides and points and any number of them can be joined together to make a 3D object.

3

A sphere can be made by joining a net of three- and four-point polygons, while other volumes such as a cylinder might have end polygons (called caps) that contain many points. Making 3D objects from polygons is called Polygon Modelling and it's the simplest and most direct way to create 3D objects. A 3D object is defined by the points that make it up, and whose locations in 3D space are precisely known by their coordinates.

3

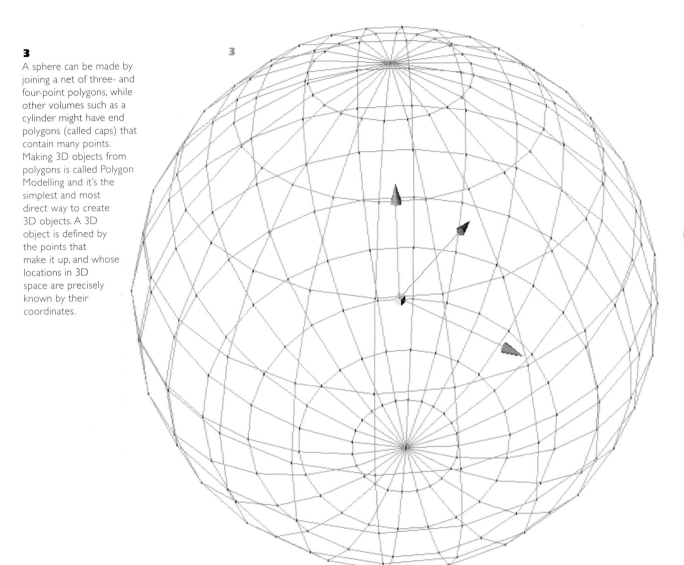

Polygons are made up of three components: points, edges and faces. These three components represent increasing levels of complexity in the structure of 3D objects. The point is the fundamental component in 3D graphics, simply defined by its three Cartesian coordinates. It is then followed in complexity by an edge, which joins two points. This is then followed by a face, which is enclosed by three or more edges.

There is another component, which is not directly editable but is nevertheless very important, called the Surface Normal. The Surface Normal is a line that runs perpendicularly from every polygon face, though by default it is set to be invisible. Normals tell the 3D program which way the face is pointing, either towards the camera or away from it, and this has important implications for shading, as we shall see later on.

TRANSFORMATION

In the world of 3D we can select and move an object to another location, just like in the real world. We don't want our sphere here, we want it there, so we move it. It is possible to do exactly the same in a 3D application – select an object and drag it on screen in the 3D or orthogonal view to another location. Another way in which to move an object, however, is to enter precise coordinate values. Almost all 3D programs allow you to see and edit an object's coordinates, so if you know that an object is 100mm high but that it's 50mm below the ground plane – i.e. its y coordinate reads –50mm – you can simply type 0mm in order to

bring it flush with ground level. A 3D object, though, has volume. By definition it is spread about in 3D space, so from what part of a 3D object does the computer measure distances and locations? Well, all 3D objects have a local centre, which is very much like the world centre (the origin). In some programs this local centre is called its Local axis or the object's Pivot Point. If the object is a sphere, for example, the Pivot Point is most likely to be bang smack at the centre of the sphere. Therefore, if you enter a value for the object's y coordinate you are really entering a value for its Local axis. It is as if the object's entire

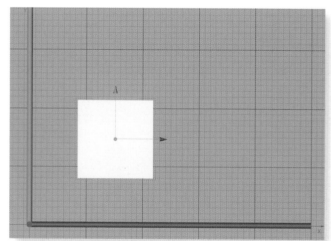

1 | 2
Local axes provide you with better options when it comes to transforming (moving, scaling or rotating) objects, since an object can be transformed relative to the World coordinate system or to its own Local axis system. When both systems are aligned there is no difference between moving an object using local coordinates and moving it using World coordinates.

42

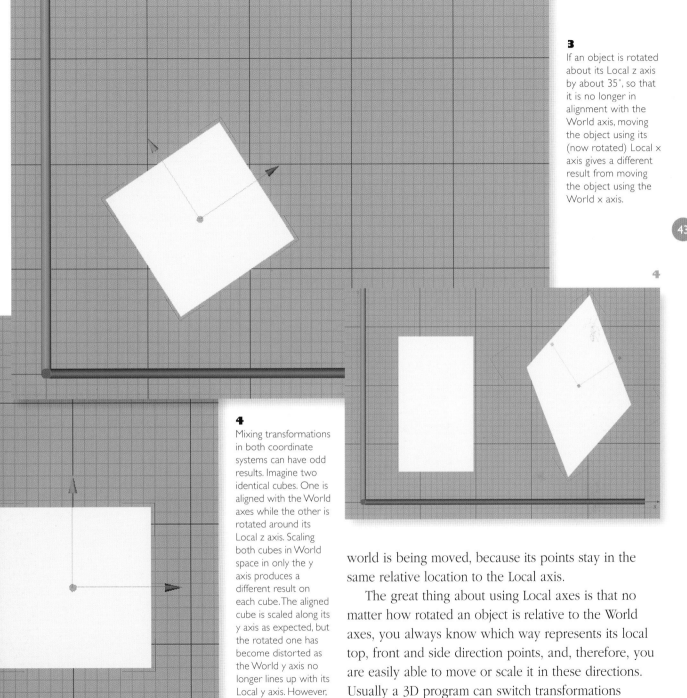

If an object is rotated about its Local z axis by about 35°, so that it is no longer in alignment with the World axis, moving the object using its (now rotated) Local x axis gives a different result from moving the object using the World x axis.

4

4
Mixing transformations in both coordinate systems can have odd results. Imagine two identical cubes. One is aligned with the World axes while the other is rotated around its Local z axis. Scaling both cubes in World space in only the y axis produces a different result on each cube. The aligned cube is scaled along its y axis as expected, but the rotated one has become distorted as the World y axis no longer lines up with its Local y axis. However, it will be obvious when to use Local or World coordinates.

world is being moved, because its points stay in the same relative location to the Local axis.

The great thing about using Local axes is that no matter how rotated an object is relative to the World axes, you always know which way represents its local top, front and side direction points, and, therefore, you are easily able to move or scale it in these directions. Usually a 3D program can switch transformations (moving, scaling and rotation) between Local and World coordinates.

MODELLING

As we have seen, the polygon is the simplest building block in 3D modelling. 3D programs let you build objects point by point if you wish, although to build a complex object such as a DC 10 aeroplane point by point would take rather a long time. Point editing is also known as low-level editing because it involves editing the model at its most elementary level. What 3D programs do, however, is provide you with a layer of tools that let you model in much broader fashion. These tools make the task of creating 3D objects much quicker and easier. But before we look at some of these in closer detail we should mention Primitive objects.

Primitives are very useful because they provide you with a set of objects that can be combined to make other objects. For example, a table can be made from five cylinders – four that have been scaled so that they are long and thin (the legs) and the other so that it is short and wide (the table top). In fact, if you look at real objects around you, you'll see that many of them can be broken down into a collection of various Primitives.

44

2

1

3

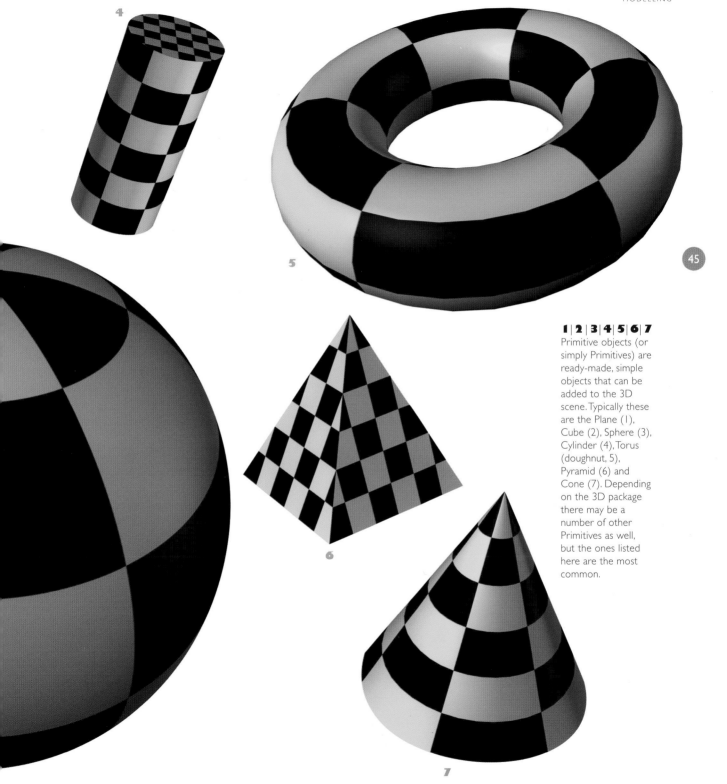

1|2|3|4|5|6|7
Primitive objects (or simply Primitives) are ready-made, simple objects that can be added to the 3D scene. Typically these are the Plane (1), Cube (2), Sphere (3), Cylinder (4), Torus (doughnut, 5), Pyramid (6) and Cone (7). Depending on the 3D package there may be a number of other Primitives as well, but the ones listed here are the most common.

HIGH-LEVEL TOOLS

When primitive modelling does not suffice, you will need to turn to the more hands-on polygon tools. These tools can be used on simple polygon shapes to create much more complex forms. They usually take the form of an action or operation that is performed on the simple object to create a complex one. The most straightforward of these is extruding. Take a planar polygon (its points all lie on the same plane so it's not twisted) and literally extrude it perpendicularly and you will get a 3D volume whose cross-section is the original polygon shape.

It is also possible to extrude selected polygons that are part of another 3D object. This provides you with a way to extend polygon objects quickly and easily. The direction and the amount of extrusion can be defined either by dragging in the view ports or by entering values. Here's where the Surface Normal can be extremely useful, because in many 3D applications you can use it to define the direction of the extrusion.

1
A planar polygon shape has been extruded in one direction to give it volume. Extruding is the simplest high-level polygon tool available in most 3D programs. The yellow line pointing away from the extruded polygon is its Surface Normal.

2
Any polygons can be selected and extruded, even if they are part of an object. Here two faces are selected and extruded to extend the object and add detail.

2

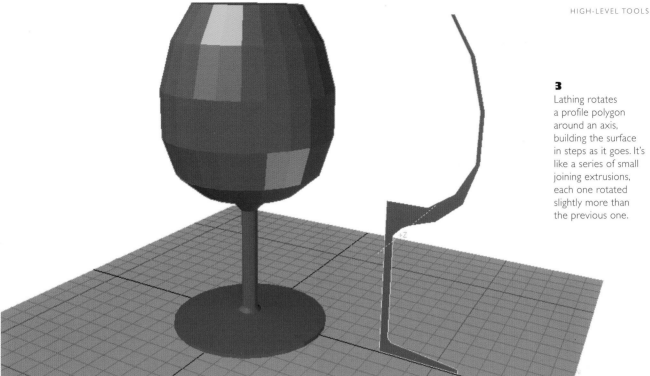

3
Lathing rotates a profile polygon around an axis, building the surface in steps as it goes. It's like a series of small joining extrusions, each one rotated slightly more than the previous one.

Lathing is another common polygon tool. A lathe operation rotates your polygon profile around an axis in order to create the 3D form. Lathed objects are rotationally symmetrical, although you can specify the starting and ending angle of a lathe to create a partially revolved object as well. Typical objects that can be created by lathing include wine bottles, axles, vases, wine glasses and car tyres – basically anything that is rotationally symmetrical.

Lofting is a further tool for creating 3D objects from a profile, or rather a series of profiles. First you create two or more polygon profiles, then position them as if they were the cross-sections of the 3D form that you want to construct. The Loft tool then connects the profiles to create an outer 'skin' of polygons, which is why this tool is sometimes called the Skin tool. Lofting can be very useful for creating more organically shaped objects, although it can be difficult to visualize in advance the shapes that you need for the profiles.

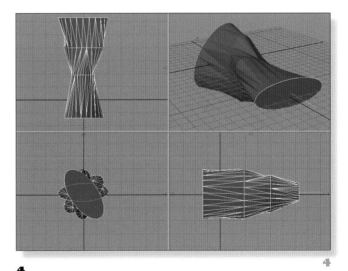

4
Four sequentially rotated polygons are lofted together to form an undulating shape. Lofting can be tricky using polygons, as you can see the object is quite angular; adding more cross-sections would produce a better result but take a lot longer.

CURVES, SPLINES AND RESOLUTION

There are more polygon tools, but it is important to introduce another geometry type before we take a look at what these other tools have to offer. So far we've seen that points in 3D space can be connected together by edges to form polygon faces, which in turn are used to build 3D models. Points can also be connected to create a curve. Curves are special objects in 3D programs because they don't render in the final image, however, it is still possible to use them as construction aids in modelling.

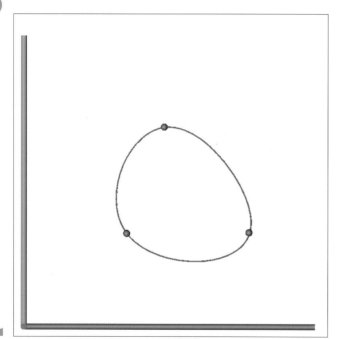

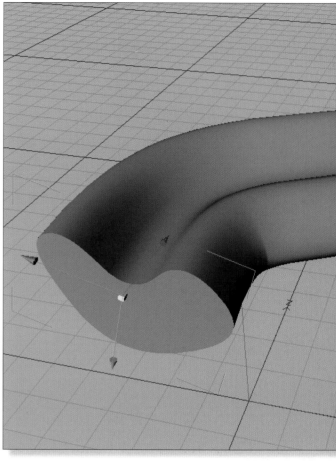

Three points are used to create a curve instead of a polygon. Curves are defined using mathematical equations resulting in smooth flowing lines, but they only need a few points in order to be plotted.

Unlike polygonal objects, which in their simplest form are nothing more than vast collections of coordinates, curves use elegant mathematical equations to define their form. If you take three points, like those used in our triangle example earlier, but tell the computer to generate a curve rather than a polygon, you will get something quite different. Unlike polygon edges, which are by definition linear, curves are, well, curved.

The most important property of curves is their economy. Imagine re-creating a curve line using points and edges, and you'll see that it would take many more points than the three used to define the curve. A lot of extra points will mean there are a greater number of coordinates that the computer has to remember at one time. Such extra data means that the object has taken up more of the computer's resources and slowed things down.

2

If curves can't be seen in the final image, then what use are they? Well, curves can be used as paths for polygon modelling operations such as Sweeping. And their mathematical nature means that they are also quite flexible. By using different types of equations, curves can have straight segments between points, which are either made to pass through the points or not, in order to produce different types of curves.

Curves are often called splines, a term that comes from the shipbuilding industry. A spline, which is a thin strip of wood or metal, was used to mark out the shape of a ship's hull. Weights would be placed along the spline that would bend the spline in predictable ways. By moving the weights, the shape of the curve could easily be changed. These physical splines were the basis of the mathematical splines that we use today in 3D programs.

3
Here are four curves. All use the same arrangement of six points, but are nevertheless different types of curve. From the top left, moving clockwise we have linear, cubic, akima and B-spline curves. There are other types too, including Bézier and NURBS.

49

2
Sweeping is a modelling operation that uses a curve as a path along which a polygon profile is swept. Sweeping can be used to create pipes, tubes, helixes and other twisting shapes.

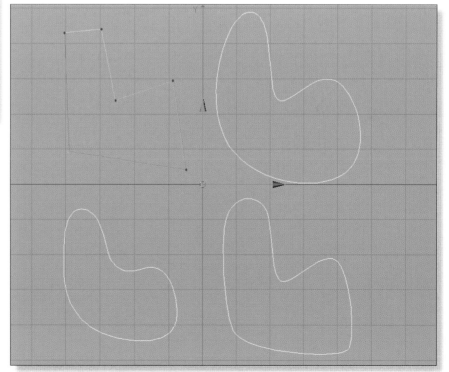

3

RESOLUTION

The problem with polygons is that to make a smooth surface you need to use a lot of them – in fact hundreds or even thousands of them. And an object that has thousands of points not only takes up valuable system resources but is difficult to work with. Selecting and editing points, edges and faces then becomes a nightmare, because there are so many of them and they all can be edited to the same degree. What would be great is to have fewer editable points to create surface smoothness, so a different approach was developed to get over the problem of how to create smooth surfaces efficiently.

1 | **2** | **3**
In these three images you can see that as the number of polygons used in the sphere increases, so does the quality of the shaded surface. This is an important issue, since in order to have a smooth surface you need lots of polygons, but this in fact makes the object difficult to work with.

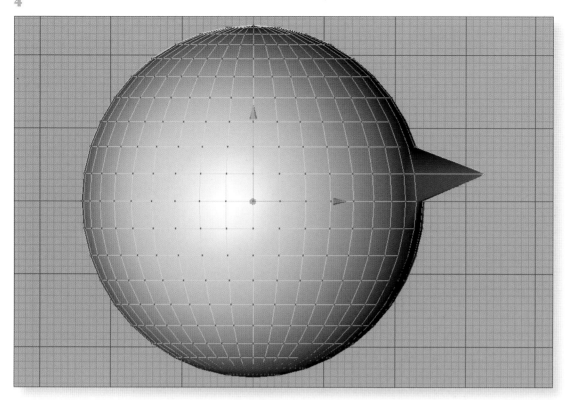

4
If you edit the points on the sphere it is very difficult to maintain the surface smoothness.

5

5
Better polygon tools have been developed in order to help with the problem, such as this Magnet tool. It provides a fall-off effect to the area selected to help smooth the point editing into the surrounded surface, but it can still be difficult to use.

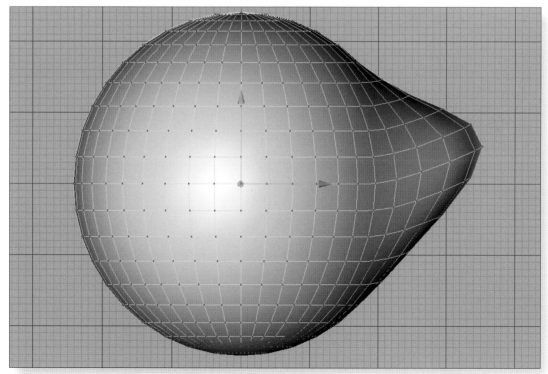

SPLINE PATCHES

Technology has now been developed that allows you to construct smooth surfaces on polygons. Rather than a web of connected polygons, a net of interconnected splines can be used instead, with the benefit that only a few points are needed to control the shape of the surface.

You can still use tools such as Extrude, Lathe and Loft, but the profiles and paths will be made with spline curves instead of polygons. Some systems also allow you to mix the two, letting you sweep a polygon profile along a spline path, for example (Lightwave is one such program). However, you can't loft using a mixture of polygons and curves.

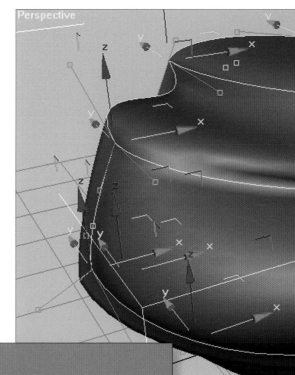

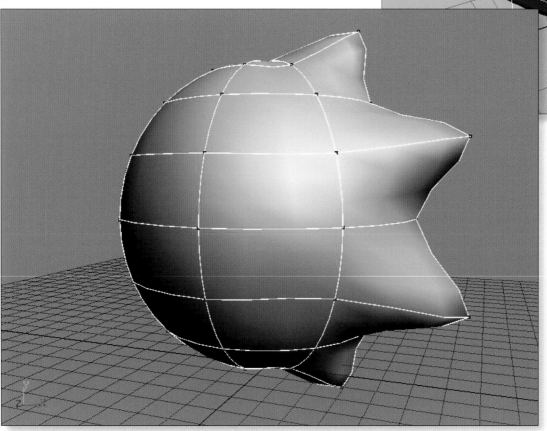

1
A surface made from a net of spline curves requires only a handful of points to achieve a smooth surface. What's more, editing the surface is much easier because there are fewer points to select and move, and the surface's natural tendency to flow from one point to the next keeps things looking smooth and organic during editing.

In order to create a surface, a grid of splines makes a network of 'patches', each of which is supported by surrounding curve points. This is why spline modelling is also known as spline patching or patch modelling.

With patch modelling you can create much smoother surfaces with fewer control points than is possible with mere polygons. In the same way as for polygons, you can also connect splines in more or less any way that you like. So triangular and square patches are supported, and you can also create a patch that has five points or more.

Because patches can be hooked together in any way that you like, there tends to be a problem with seams appearing in the surface, especially if you are using less regular construction methods. While patches are relatively easy to work with, in the early stages of model-making they do have a tendency to look angular or lumpy. They also require a lot of manual tweaking of points to get them to run smoothly into one another.

Patches that are placed along continuous stretches of a curve are usually fine, but where two unconnected surfaces are hooked together you invariably get a seam or a crease that can prove difficult to remove.

53

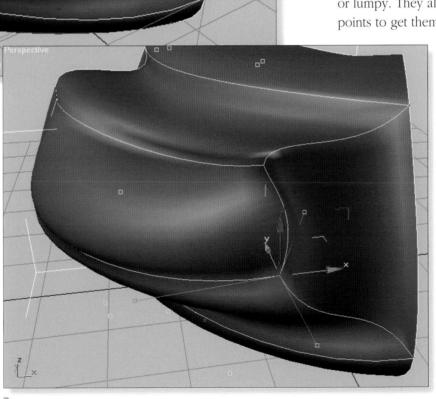

Perspective

3

2 | 3

This organic form was created from spline patches. You can see that each point on the surface, as well as having a location, has handles that control the shape of the curve going through it. Depending on the number of curves passing through the point there may be four or more handles to control. Each can be moved independently of the others so it's easy to create creases between neighbouring patches. Editing spline patch-based models can be tricky, though it varies from program to program.

BÉZIER SPLINES AND SURFACES

Some 3D programs have another type of curve that is known as a Bézier curve. These operate in much the same way as they do in 2D programs such as Photoshop and Illustrator. On each point in a Bézier curve there is a tangent handle that allows you to modify the curvature of the curve at that point.

This type of curve offers much more flexibility since you can create smooth, broad curves or sharp curves using a single point. By breaking the tangents you can also create discontinuities in curves, which requires close or overlapping points with traditional splines.

Bézier surfaces also have points with tangent handles. With a single curve there is one pair of handles per point, but on a surface there are two pairs. Though Béziers are flexible, you can end up with a lot of extra surface points to edit – tangent handles, since you have four of these per point, all over the surface.

54

2

Perspective

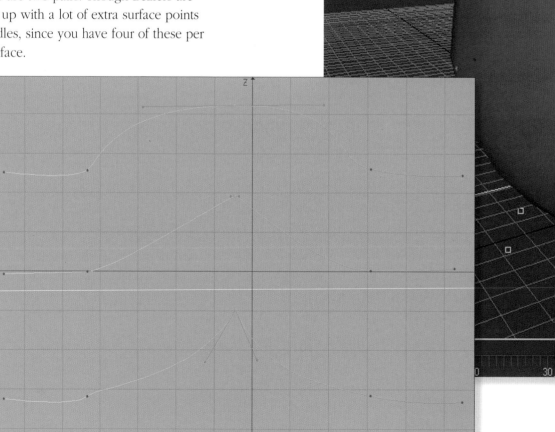

1
Bézier curves have points with tangent handles. The top curve has a broad curvature at the selected point because the tangent handles have been extended outwards from the point. The centre curve has a very sharp curvature at the selected point because the handles are very near it. The bottom curve has 'broken' handles to create a discontinuity, or cusp, in the curve.

1

2
Bézier surfaces have
points that display
two pairs of tangent
handles (the green
dots in the image),
one pair for each
surface direction
u and v (see *page 57*).

Cancel Expert Mode

40 50 60 70 80 90 10

NURBS

There is a special type of spline that has found favour in 3D graphics due to it having some particularly useful properties. NURBS (Non-Uniform Rational B-Spline) offer greater functionality than Béziers, though at first it may appear that they have less.

NURBS, like simple splines, use control points to define a curve. There are no tangent handles as there are on Béziers; instead they have NURBS points, which from here on in we'll refer to as CVs (short for control vertices). These can be weighted to affect the curve at their particular point to a lesser or greater degree.

Part of a NURBS curve's mathematical description is its Degree. A Degree 1 NURBS curve is linear, which means that it has straight segments between each CV. If you raise the degree of a NURBS curve to 2, 3, etc. then the curve becomes smoother. The most common degrees for NURBS are Degree 2 (quadratic) and Degree 3 (cubic).

Understanding the maths is not really essential, but it will help if you understand the options you have when working with NURBS. Another difference between NURBS and Bézier curves is that NURBS never pass through their CVs, except (as usually implemented in 3D software) at their end points. The only exception to this is if the NURBS curve is Degree 1 (linear).

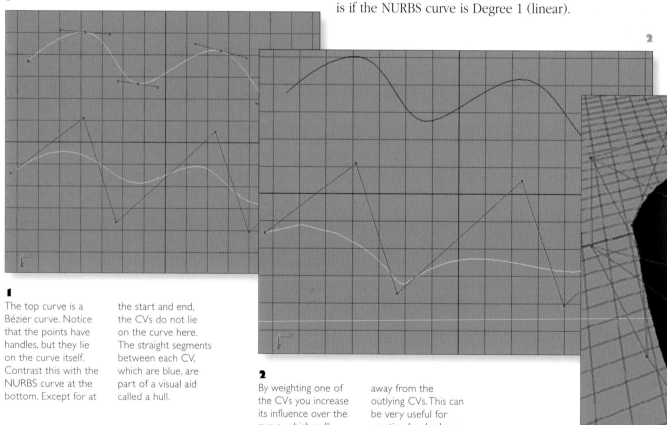

1

1
The top curve is a Bézier curve. Notice that the points have handles, but they lie on the curve itself. Contrast this with the NURBS curve at the bottom. Except for at the start and end, the CVs do not lie on the curve here. The straight segments between each CV, which are blue, are part of a visual aid called a hull.

2
By weighting one of the CVs you increase its influence over the curve, which pulls closer to it and further away from the outlying CVs. This can be very useful for creating hard edges on NURBS models.

2

3

NURBS Primitives can also be created and then sculpted by moving their points; however, unlike polygon objects, whose surface structure can be made up in any way that you like, NURBS surfaces have an extremely rigid topology (surface structure) that is basically like a grid. On a NURBS sphere each spline curve that defines its surface either runs from pole to pole or parallel to the equator. These two directions of the NURBS surface are called u and v, and are similar to an x y coordinate system. When editing NURBS surfaces you must move the points because there are no edges or faces as such. That means that you cannot extrude faces or add details to portions of the model in the same way that you can with polygons meshes (or indeed spline patches in some

programs). However, it is possible to add extra detail to the surface by adding a new row or column of CVs in between two others. Of course the new set of CVs has to go right the way around the model, increasing the point count in places where you may not really need it. This is, fortunately, one of the very few downsides of NURBS surface modelling.

4
You can increase the detail of a NURBS surface by adding an extra row or column of CVs to it. Here an extra row has been added to the object on the right and scaled up to produce a goblet shape.

57

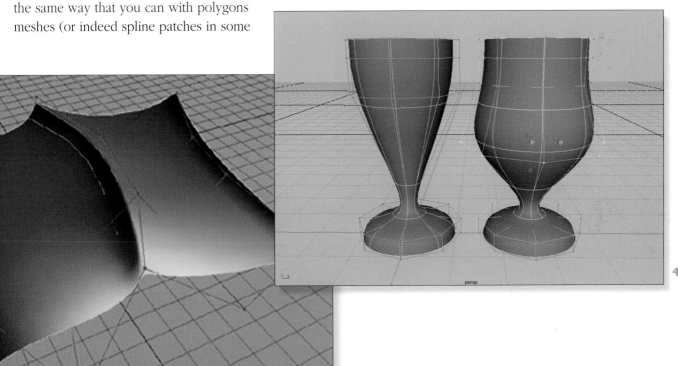

3
With a NURBS object, the CVs lie outside the surface that they control. You can sculpt the surface by moving the CVs, just as with patch surfaces, and you can also weight the CVs.

persp

4

SUBDIVISION SURFACES 1

There is a geometry type that combines the natural smoothness of NURBS with the ease of use and flexibility of polygons. These are subdivision surfaces and they offer a simple way to model both organic and mechanical objects with very few compromises.

Subdivision surface modelling works by taking a base model, usually a polygonal model, which is a very rough description of the shape you want to create, and then applying a series of subdivision routines to it that simultaneously smoothes the model and increases its resolution. However, subdivision surface modelling maintains a link between the original low-resolution polygon mesh and the higher-resolution, smoothed surface. This means that you can continue editing the

2
Once the subdivision is applied, the original low-resolution surface disappears, leaving just a wireframe cage object with the smoothed surface beneath. Note that the smoothing operation always results in a reduced volume.

1
Here is a low-resolution polygon model (torch) before it's converted into a subdivision surface model.

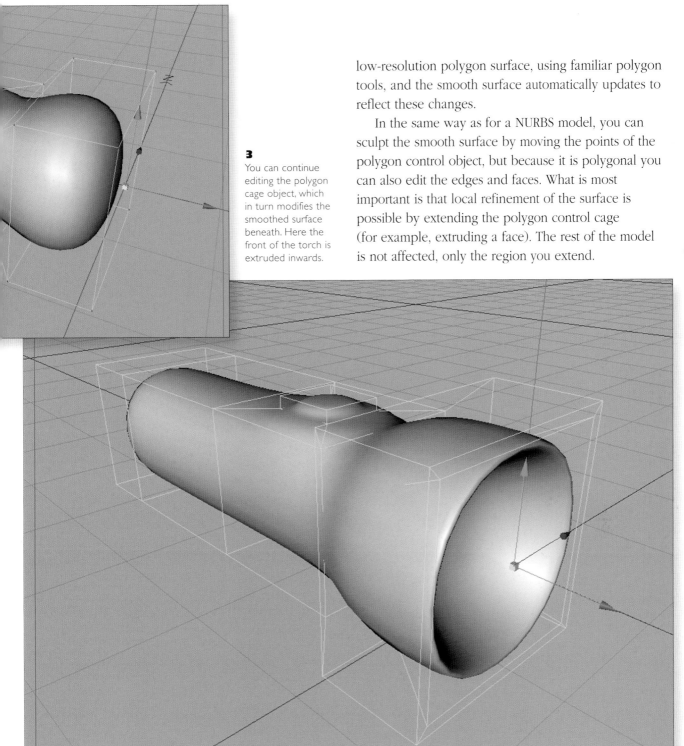

low-resolution polygon surface, using familiar polygon tools, and the smooth surface automatically updates to reflect these changes.

In the same way as for a NURBS model, you can sculpt the smooth surface by moving the points of the polygon control object, but because it is polygonal you can also edit the edges and faces. What is most important is that local refinement of the surface is possible by extending the polygon control cage (for example, extruding a face). The rest of the model is not affected, only the region you extend.

3
You can continue editing the polygon cage object, which in turn modifies the smoothed surface beneath. Here the front of the torch is extruded inwards.

59

3

SUBDIVISION SURFACES 2

The other great feature of subdivision surface modelling is that because the cage object is polygonal, you can create models with totally arbitrary topology, unlike the regular u and v patchwork of a NURBS surface. In some of the better subdivision surface implementations you may also use polygon faces that have any number of points. Most current systems limit you by requiring that polygons have only three of four points, but this is a relatively minor restriction considering the other benefits. Some systems let you use n-gons (polygons with an arbitrary 'n' number of points) in the polygon control cage. However, many 3D modellers tend to stick with quads because, topologically speaking, it makes modelling easier in the long run.

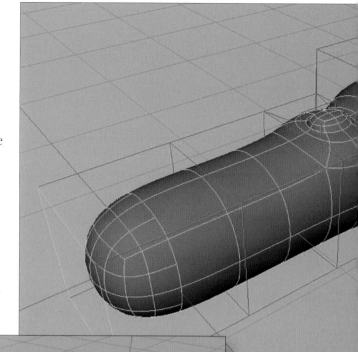

persp

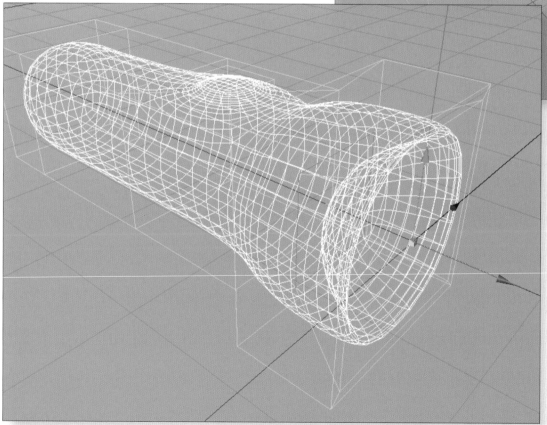

In wireframe mode you can see the increased resolution of the subdivision process. You can specify the number of iterations that the subdivision process goes through to create an object of the desired resolution. This value can be changed at any time, since the surface is 'live'.

2 | 3
The end of the torch is rounded, a natural result of the smoothing process (*left*). But by selecting the edges at the back of the torch you can set them to be a full crease, resulting in a hard edge (*below*).

Like NURBS, subdivision surfaces can be weighted so that sharp creases and edges can be created on otherwise smooth and flowing surfaces. This means that, for example, you don't need to add extra geometry in order to make the edges of a cylinder hard. Both edges and points can be weighted or creased, although not all 3D programs support both options. With those that let you weight points and edges, some let you apply any weighting value while others restrict you to full or partial creasing. Some creasing is better than none, of course.

61

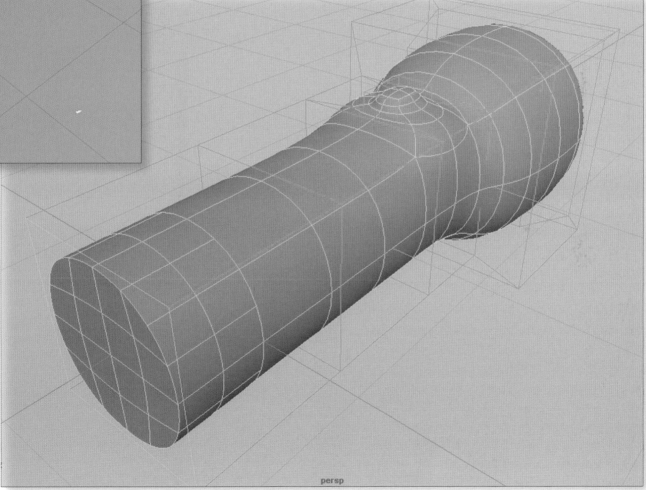

persp

3

GEOMETRY USES

There are no hard-and-fast rules when it comes to choosing which geometry type to use for a particular task, but here are some pointers. For mechanical modelling and illustration or Web design you can use any type of geometry so long as the object looks right.

In CAD/CAM, NURBS and Solid geometry are often used because they can easily and accurately represent the specific shapes and structures that are being created. They can also be analysed and measured in ways that simple polygon objects can't be, providing the degree of accuracy demanded by the industry.

For character animation, Bézier patches and NURBS are very useful because the surfaces can be deformed without kinking or ripping apart. The low point count also makes them easier to deal with when setting them up for animation. However, creating a detailed bipedal character from a single NURBS surface is almost impossible, so special tools have been designed that enable multiple surfaces to be stitched together. This can cause problems during animation as poor modelling and stitching may result in surfaces literally coming apart at the seams.

At the end of the day you can use whatever type of geometry you are most comfortable with. Some 3D artists prefer NURBS, while some prefer polygons, but it often depends what industry they work in as well as which toolset they feel most adept at using. Sometimes the extra work involved in getting, for example, a NURBS model to hold together during animation is worth it if the 3D artist feels that he or she is better at modelling using NURBS than with a simpler geometry type.

1
A NURBS object is used to create a model for CAM (Computer Assisted Manufacturing) purposes. One of the properties of NURBS is that the surface curvature can easily be measured.

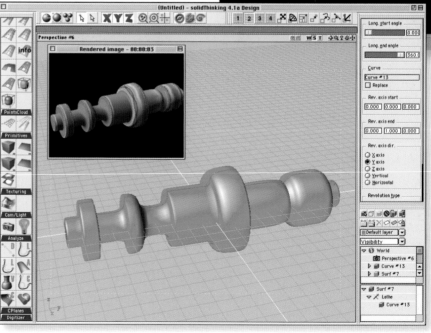

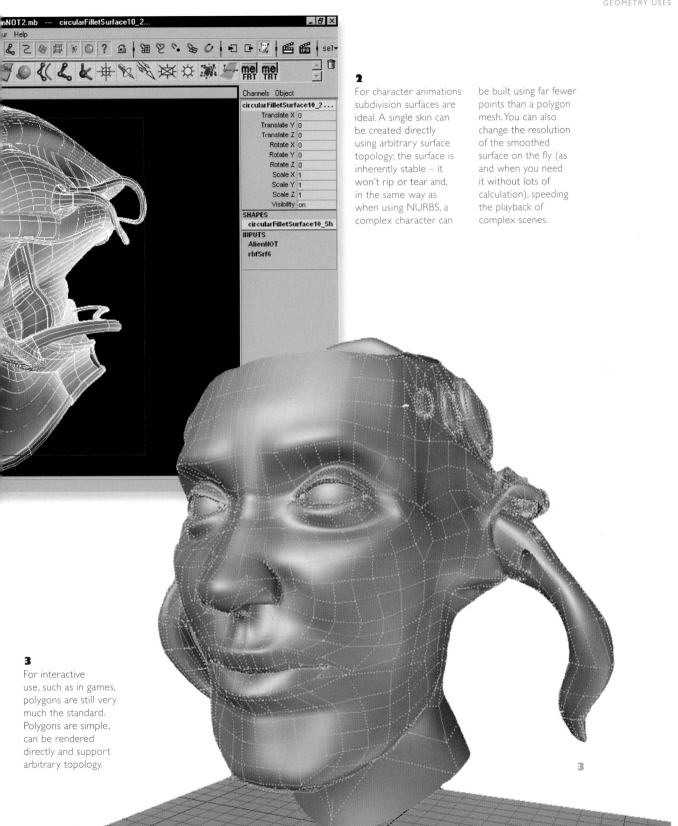

2
For character animations subdivision surfaces are ideal. A single skin can be created directly using arbitrary surface topology; the surface is inherently stable – it won't rip or tear and, in the same way as when using NURBS, a complex character can be built using far fewer points than a polygon mesh. You can also change the resolution of the smoothed surface on the fly (as and when you need it without lots of calculation), speeding the playback of complex scenes.

3
For interactive use, such as in games, polygons are still very much the standard. Polygons are simple, can be rendered directly and support arbitrary topology.

3

SHADING 1

The end result for the work you do in a 3D program is, most of the time, a 2D image or animation. In order to produce that image, the 3D software has to fill in all the polygons and surfaces you've built to make them appear solid, add in the lighting, calculate any materials and textures you've defined and process any special effects you might have added. This is a process called rendering and it can take a while to carry out, which is why some understanding of what is going on will pay dividends if something isn't looking quite how you hoped it would.

Although the mathematics involved are quite complex, some of the concepts are easy to grasp. A cursory understanding of the processes will help you to create better models and images, design better lighting set-ups and solve more quickly any problems that you might have.

Shading is the process of filling in the polygons of a 3D mesh object with a colour so that objects appear more like they do in the real world, rather than as a mesh of lines and points. There are many different types of shading 'models' available in 3D graphics that are suitable for different purposes. The term 'model' is used because the shading techniques were designed to model the way light interacts with objects and our eyes to produce an image.

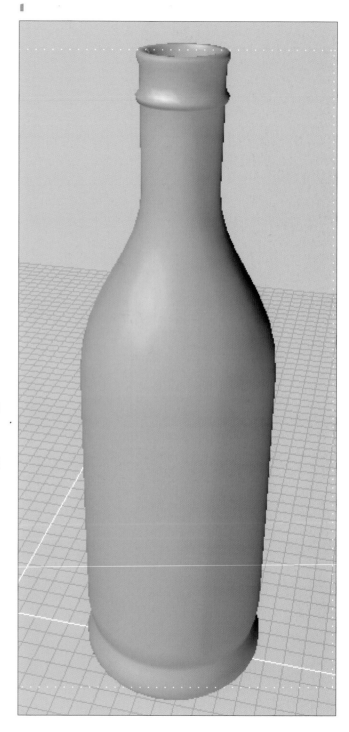

1
Smooth shading shows objects as solids.

2
Textured shading using OpenGL (*see page 66*) is used to show an environmental reflection image on the bottle.

3
Here is the polygon mesh, displayed in all its glory. For a NURBS object this might be the tessellated surface for rendering.

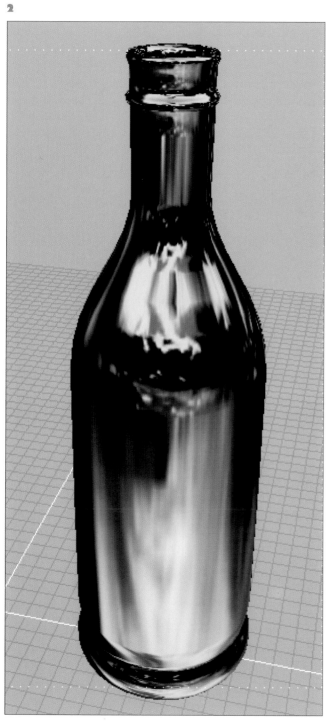

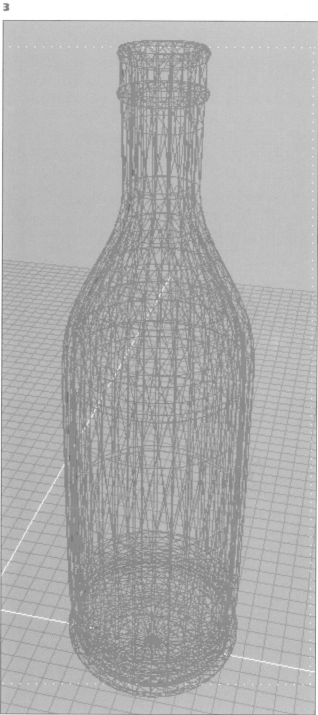

SHADING 2

Most 3D systems can display fully shaded 3D objects in their viewports, which helps us immensely in visualizing the object. This is thanks to specialized, fast-rendering algorithms that have been developed to be accelerated using hardware. OpenGL, developed by SGI Inc., is the pre-eminent display rendering technology that is used by today's 3D artists and supported by 3D software. There are other graphics Application Programming Interfaces or APIs, as they are known, such as Heidi, DirectX and the now little-used Quickdraw 3D. However it is OpenGL that has become the industry standard for fast 3D displays because of its ability to show smooth shading, textures and effects in real-time on desktop PCs.

Wireframe views are equally helpful because they let you examine the surface structure much more clearly. As you work you will often flip between the two display types, depending on the task at hand. Other display types include Point Cloud, where only the points are displayed, and for parametric surfaces there's Isoparms display, which just shows the surface contours (not the tessellated wireframe surface). Probably the simplest display type, however, is Bounding Box. In this, objects are displayed by a box representing their bounding volume. This is very fast and is good to use on slower systems with more complex scenes, though it's only really useful for testing motion, and maybe composition at a push.

1
Isoparms display used on a NURBS object. Isoparms display is very fast compared to shaded displays, but is only suitable for parametric surfaces and procedural objects.

2
Point Cloud only displays the points. It can be used with all types that have vertices as part of their geometry. It is useful for polygons and parametric surfaces.

3
Bounding Box displays the bounding volume as a simple wireframe cuboid.

2

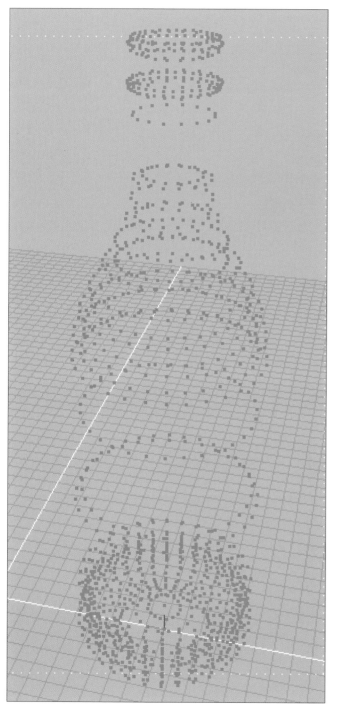

3

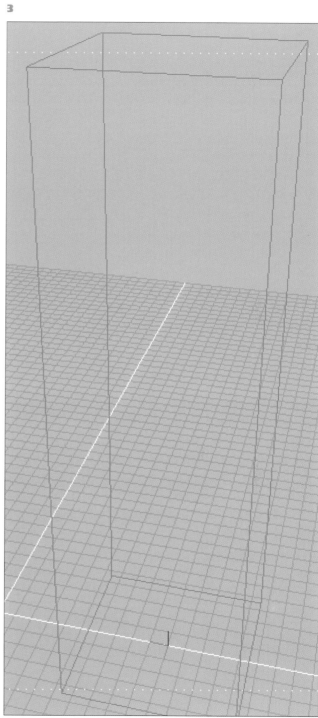

SHADING 3

In order to calculate the colour of polygons so that they can be shaded, a virtual light source must initially be defined in the scene. Then the computer is able to calculate what colour the polygon will be, based on its angle to the viewpoint and the light source. The most basic type of shading is known as flat shading. Using this technique, each polygon is filled in with a single colour, depending on its direction and the location of the light source as well as the light colour and intensity. There are other parameters that are taken into account, but that is the basic process, so we'll keep things pared down for now.

The information about the direction of a given polygon is derived from what is known as the Surface Normal – this is the imaginary line that points out from a polygon face and is perpendicular to it. When it comes to flat shading this is all the information that is required, hence the faceted appearance. Another approach, known as Gouraud shading, uses the Normals at the vertex of each polygon in order to gain its information. The colour of a facet is then interpolated across the face from the value found at the vertices. This gives a smoothed appearance to the model.

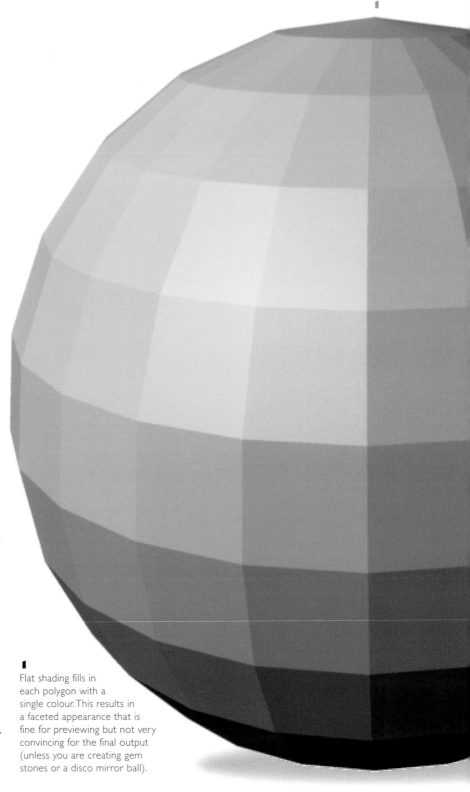

Flat shading fills in each polygon with a single colour. This results in a faceted appearance that is fine for previewing but not very convincing for the final output (unless you are creating gem stones or a disco mirror ball).

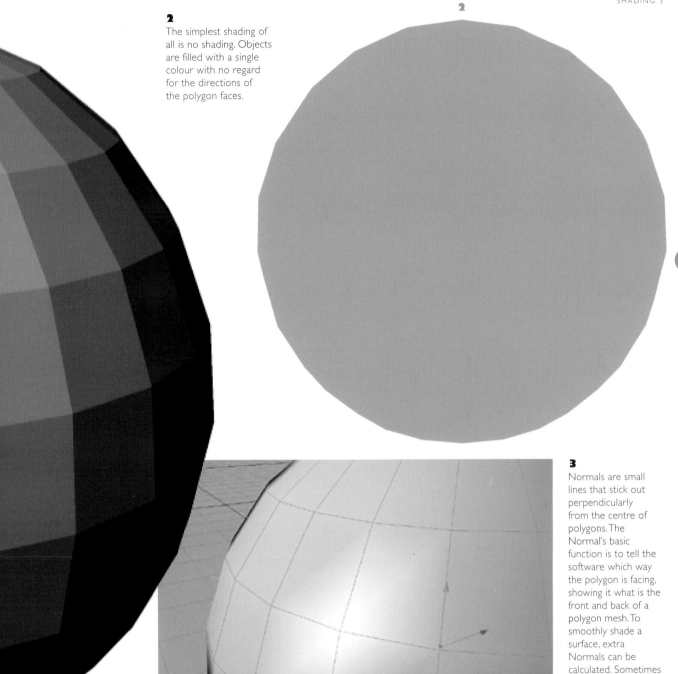

2

The simplest shading of all is no shading. Objects are filled with a single colour with no regard for the directions of the polygon faces.

2

3

Normals are small lines that stick out perpendicularly from the centre of polygons. The Normal's basic function is to tell the software which way the polygon is facing, showing it what is the front and back of a polygon mesh. To smoothly shade a surface, extra Normals can be calculated. Sometimes bad Normals occur on an object, and these must be repaired or you will suffer nasty artefacts when the object is rendered in the final image.

3

SHADING 4

These shading algorithms were developed by people who were doing research into computer graphics and, as a result, they often bear the names of their developers. Some 3D programs offer even more shading types, such as Lambert, which produces smooth shading but without highlights, which is good for matt surfaces. Other shading algorithms include Blinn shading, which is similar to Phong shading but with more accurate highlights, Oren-Nayer shading, and Cook-Thorrance shading, to name but a few.

1

Gouraud shading averages the colours found at the vertices across the polygon faces, resulting in a smoothing of polygon boundaries. This gets rid of the faceted appearance inherent in flat shading, though there are some problems such as artefacts, especially on low-resolution models (note the edges of the sphere). Gouraud shading is also not very good at reproducing highlights on objects.

2

1

2

A better method is Phong shading, which interpolates the Normals themselves and produces a new Normal for each pixel in the final image. It uses Gouraud techniques to do this, then produces the shading – more Normals equals better shading. It calculates highlights on objects much more accurately than Gouraud, so Phong is often used for final output.

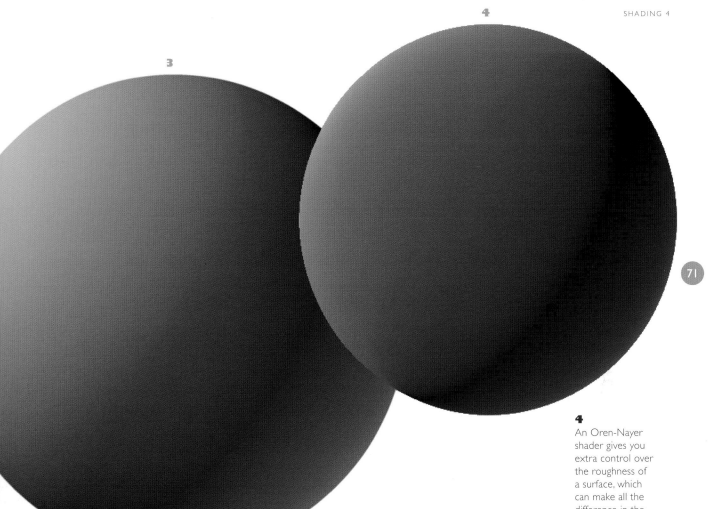

4
An Oren-Nayer shader gives you extra control over the roughness of a surface, which can make all the difference in the credibility of a model.

3
As you get better at 3D design you will become more aware of subtleties in nature. Having a good eye for surfaces, and how they react to lighting, will be a great help when it comes to creating stunning 3D imagery. Imagine you are trying to re-create a matt surface such as rough paper – simply turning off the highlight on an object's material will not always be enough to simulate the effect.

By choosing the best shading model for an object you can arrive at much better results and save time into the bargain. For example, Blinn shading is often used for metallic objects, while Phong shading tends to be more suitable for plastic objects. If you can choose a Blinn shader then there's no point in struggling to get a Phong-shaded object looking right. Likewise the Oren-Nayer shader is extremely good for creating rough, matt surfaces, which are more than simply surfaces with no highlights.

ILLUMINATION

When an object is illuminated by a light source there are three distinct areas to its shading. To see this, get a desk lamp and something shiny, such as an apple, and hold the object under the light. You'll notice that there is a very strong point of light, a hot-spot on the apple on the side towards the light. The part of the surface facing away from the light is dark (though not totally black), and in between there is a gradual fall-off of shading from the bright hot-spot to the side in darkness. This is all due to two basic components of an illuminated surface, the Specular and Diffuse shading. We said there were three main areas to the shading, but only named two. That's because the third is slightly difficult to define. But, although the side of your object opposite to the light is dark, it's not totally black either. This is due to Ambience, or Ambient shading.

Ambient shading is a bit difficult to define. It's the illumination that is produced in an environment by other objects redistributing the light from the main light source. In a room with a window open to the sunshine, even in corners not directly illuminated by the sun,

you'll notice that it is not totally dark. This ambient light bounces around illuminating everything, so that nowhere that light can reach is totally black.

To mimic bounced lighting in a computer is very expensive, computationally speaking, so a quick and dirty approximation, called Ambient lighting, is used. It varies from system to system but most follow a similar method. A global Ambient level is set for the scene, which usually ranges from 0 per cent (no illumination) to 100 per cent (full illumination). The Ambient shading property of an object can be altered so that it is affected to a greater or lesser degree, just as you can alter the Specular intensity. A higher Ambient shading level on an object makes the unilluminated portions lighter.

By having two controls for Ambient illumination you can change this portion of the scene lighting globally or for each object. However, Ambient light is just a fudge, and it can make your images look awful. It is usually much better to use low-intensity scene lights to brighten dark areas and simulate ambient lighting than to resort to Ambient light.

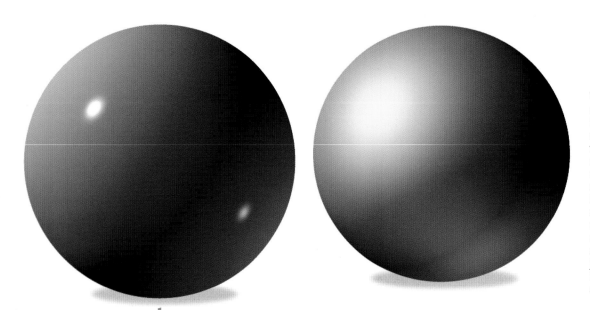

When an object is shiny and polished, the Specular highlight is bright and small, but as you roughen the surface it becomes dimmer, broader and more diffused. As we have seen, turning off the Specular component for a surface makes it appear matt, although you can create even stronger matt surfaces by altering not just the Specular but the Diffuse component too, as in Oren-Nayer shading.

2

2
The image above shows a simple scene without any global ambient light.

The areas that are not directly illuminated are totally black.

3

3
A small amount of Ambient shading lightens the darker area, but also seems to be impacting the quality of the image. There is a lack of contrast to the image that looks quite unlike the effect of real ambient light.

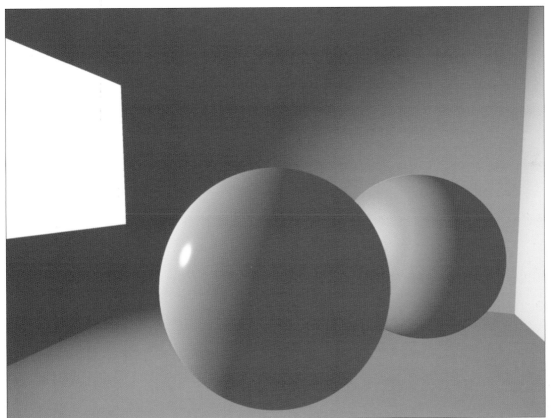

4
A high Ambient level has totally destroyed the shading in the image, rendering it flat and lifeless. Notice that in the top left corner of the room you can't make out any difference in the illumination between the two walls.

4

SPECULARITY

Strictly speaking all objects are reflective. This means that they return some of the light that they receive back into the environment. Much of the light is diffused – the light penetrates the surface and bounces around before emerging at some odd angle. This is why the term Diffuse reflections is used when describing this property. Specular reflections are produced when the angle of reflection equals the angle of incidence. This is shown in the diagram below.

The reflection effect we are used to in a 3D application is simply referring to returned light from a surface that has not been sufficiently diffused so that a recognizable image can be discerned. Specular reflections are reflected images just the same – images of the bright light source.

Because lights don't really 'glow' in a 3D program you really need to have a Specularity control in order to fake the effect, unless you set up a visible luminous object where your light is and render with raytraced reflections, but this is overkill. However, having said that, there are techniques that involve creating specular highlights with reflected geometry, and these are especially useful when a light source is spread over a wide area such as a window.

▮ The two grey lines represent light rays that have been diffused by the surface so that its incoming and outgoing angles relative to the surface are not the same (producing Diffuse illumination). The red line represents a ray producing a Specular highlight from the camera's point of view. This ray's incoming and outgoing angles are equal, relative to the surface. As you can see, a Specular highlight appearing on an object's surface is dependent on the relative positions of the light and the camera. That is why the Specular highlight on an object appears to move when you move your viewpoint (or the light for that matter).

74

Light ◯

Camera

Object

▮

Sometimes shading models are built in to an
application's rendering engine (the part of the
program that generates the image), and in other
systems it is possible to apply different
shading models on an object-by-object
basis. These add-ons to the rendering
engine are known as Shaders, because
they effect the shading process.
However, many rendering
systems let you plug into all parts
of the rendering pipeline in order
to create many different effects,
and the term 'Shader' can be
applied to any piece of code
that modifies the rendering
process. Shaders can be
illumination models, as we've
seen on the previous pages
(*see pages 72–73*), texture
generators, light effects or
camera lenses. It is also
possible to have Utility Shaders
that measure a certain property
of a surface and pass it on to
another Shader for some other
operation, like controlling the
amount of transparency.

2
This image of a
reflective sphere was
created using a 100
per cent luminous
window model to
provide the Specular
highlight. The model is
made from just four
polygons, and
raytracing (see *page
88*) was used to
make it reflect in the
sphere's surface. A
light was positioned
in front of the
window model to
provide illumination
for the scene.

USING IMAGE MAPS

The great trick with 3D graphics is that it is possible to take an image, painted by hand or photographed, and then wrap it around an object. If the image is of a plank of wood, then the finished object will appear to have a wooden surface. Use a photo of a rusty metal plate and your object will look like a rusted metal plate. A combination of clever modelling and texture maps can be used to imply a great deal of detail without actually having to build it.

Image maps are very useful, though getting a certain look is not always quite that simple. All objects have a number of different properties that make them look like what they are. Wood has a colour pattern (the grain), which can be captured in a photo, but it also has certain shading properties that cannot be captured and fed into the computer using a photograph.

If the wood is from a palette or crate, for example, it is likely to be very rough and have few or no specular highlights. It may also have a textured or bumpy surface that can't be directly photographed. These parameters must be set up in a material definition by the artist, but the key to getting the look right is being able to identify these properties or qualities in the first place.

The wood image is an ordinary RGB (the red, green and blue components that make up a full-colour image on a computer) file that is used to determine the colour of the object at each pixel. However, other factors, such as the colour of the light source and the shading model, contribute too. What the RGB image really does is define a raw base colour for the object. Of course if you put this object in a different scene with different settings, the object will look slightly different, but it will still have the basic wood pattern.

1 | 2
An image of a piece of wood has been wrapped around this sphere and used as the colour portion of the object's material definition. It looks as if it is made of wood, but it is not entirely convincing.

We can use image maps to drive other material parameters too. Bump mapping is one of the most important uses for image maps, and along with the colour map, goes a long way to fooling the eye into believing that it is seeing a real object. A bump map needs to be a greyscale image of the texture that you want to simulate. Although the wood image is in colour, you can take it to a 2D paint program such as Photoshop and then turn it into a greyscale image for use as a bump map. As the bump map is derived from the colour map, the features in both will line up, which further adds to the effect. Using the colour map for the bumps does not provide an accurate description of the surface texture of the wood, but is often used, especially if time is of the essence.

77

3
The RGB wood image is duplicated and converted to a greyscale image and is then saved.

3

When it is rendered with a bump map the surface of the sphere displays a grain texture just as if it were the real grain. The relief is an effect that is produced by carefully manipulating the interpolated Surface Normals pixel by pixel. Precisely how this technique works is not really important, but what is important is the relationship between the shades of grey in the bump-map image and the effect that you see rendered. Basically, white areas in the greyscale wood image produce highs or ridges on a surface, while the black areas produce lows or grooves. In between there is a smooth graduation in height. This effect is caused by playing with the Normals so that they aren't really bumps, geometrically speaking. Extracting the greyscale information from an RGB

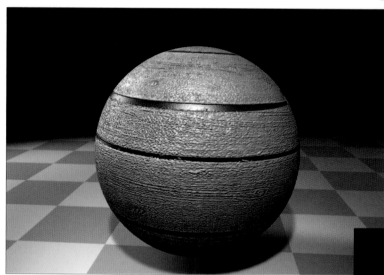

5
To make the bumps more prominent you can increase the specularity of the surface. Now it looks as if it has received a coat of varnish, but you can see the effect of the bump map more clearly. Notice how the black lines in the image appear as deep grooves.

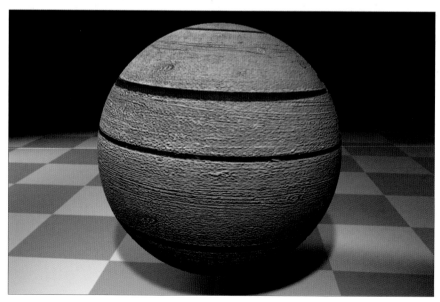

4
When applied to the bump channel of the material, the greyscale image produces a texture or relief on the surface. Areas that are black in the image represent low points and areas that are white are high points.

image is the simplest way to get a bump map, since you can't photograph such things in reality. However you can also use the RGB image directly in many 3D programs as a bump map without first having to convert it to greyscale. The program will do the conversion internally at render time, though for better control over the end result you will probably want to do it yourself.

A better way to capture a surface's texture is to take a rubbing or an imprint of it. 3D artists have been known to cover their own faces with a light coating of ink or paint and then press it onto a piece of paper in order to extract their own skin bump textures!

By changing the colour and bump maps applied to the sphere pictured, you can turn it into a different object entirely. As mentioned, you can use photographs for image maps but you can also create them from scratch. By painting image maps you can create any kind of object look you want, be it realistic or totally stylized.

6 | 7
By replacing the colour and bump maps for the sphere with the 8 ball colour and bump maps, we've created a pool ball instead.

CONTROLLING MATERIAL CHANNEL INTENSITY

Colour and bump mapping are special cases as far as image maps go, but all the other properties that a material possesses can also be controlled with a map. Transparency, reflection, specular intensity, luminosity and Diffuse channels can all be controlled using an image map, for example. In all these cases, though, the image map serves to vary the intensity of the channel across the object's surface, and in the same way as for bump maps, black equals a low effect, white equals a high effect and shades of grey produce a variation in between.

The following five examples show the effect of a single-texture black-and-white map as it is applied to each of an object's material channels in turn.

80

1

This is the texture that was used, a mottled black-and-white image. The strong contrast should show off the effect well. Remember that it is the image that controls the effect. Wherever the image is white, the channel is at 100 per cent intensity; where it is black, it is at 0 per cent intensity. Note that in each of the subsequent pictures the image is wrapped around the sphere in the same way each time.

3
Image applied to the Reflectivity channel.

2
Image applied to the Transparency channel.

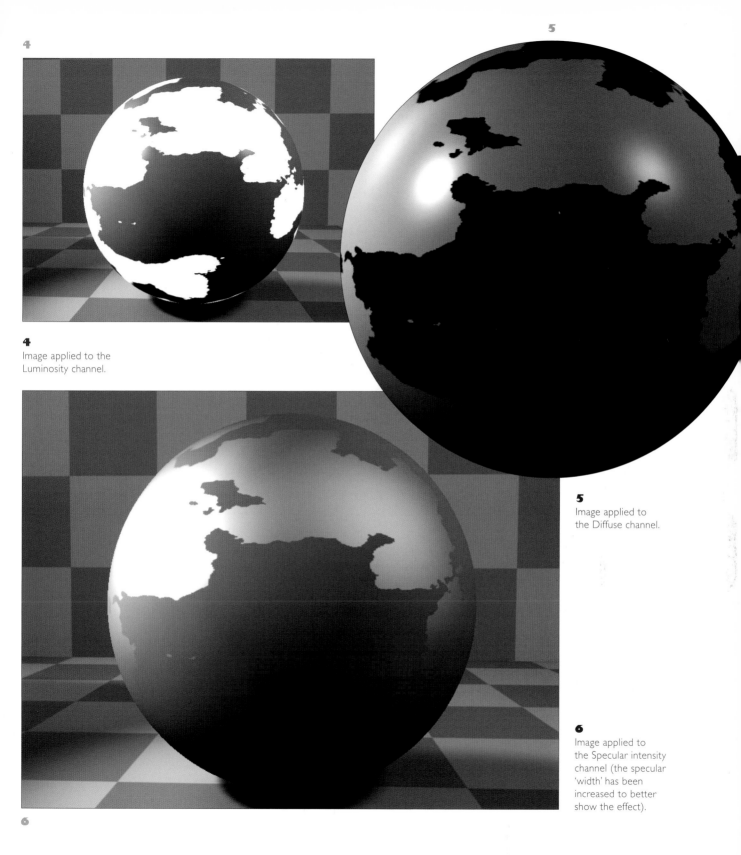

4

4
Image applied to the
Luminosity channel.

5

5
Image applied to
the Diffuse channel.

6
Image applied to
the Specular intensity
channel (the specular
'width' has been
increased to better
show the effect).

6

BUMPS VERSUS DISPLACEMENT

Bump mapping is an effect, a virtual trick of the light. The surface of the object does not change at all – it is only the shading of the object that is modified in order to give the impression of texture or relief.

Bump mapping is good for small details, such as the pits in a golf ball, the grooves in wooden floorboards, skin and scales, brickwork and so on. However, larger surface details are better modelled rather than bump-mapped, because the trick will become obvious at some angles.

1

2

1 | 2

Here is a bump map that has been applied to a sphere. When you are not too close, the bumps look convincing enough, but if you zoom up to the edge you'll notice that it is perfectly flat. If these were truly bumps the silhouette would also be bumpy. You'll also notice that the bumps tend to look distorted too.

83

3
A displacement map
was used instead of
a bump map here.
Notice that the edge
of the sphere is
bumpy, because these
are real bumps.

There is a way to create real
bumps on surfaces – by using
displacement mapping. In the same
way as in bump mapping, a
greyscale image is used to define
high and low areas. However, this
time the information is used to
move the points on a polygon mesh
surface in the direction of the
polygon Surface Normals so that the
surface becomes bumpy. In order
for displacement mapping to work
well you must have a lot of
polygons, because the detail is
limited by how finely subdivided the
surface is. However, by combining
bump mapping and displacement
mapping you can arrive at a very
realistic, detailed look.

ENVIRONMENT MAPPING

Raytraced reflections are accurate but they can take a long time to render (*see page 88*). You can fake reflectivity by using image maps, just as you can use them to fake bumps, colour or any other property.

By applying an image of an environment, such as a landscape or a room, and projecting it onto an object from an imaginary sphere that surrounds it, it appears as though the object is reflecting its environment. No rays need to be cast since it's just a shading technique, so it is very fast to calculate. Because the projection sphere is infinitely large and not actually connected to an object, as the reflective object moves and rotates in the scene the environment image moves over its surface, distorting as it does so, just like a real reflection would.

Environment reflection maps can be used to great effect on all objects that require reflections. They work especially well for objects that are not highly reflective since the minor limitations are not visible. For very reflective objects, where accuracy is important, then raytracing is the better option.

84

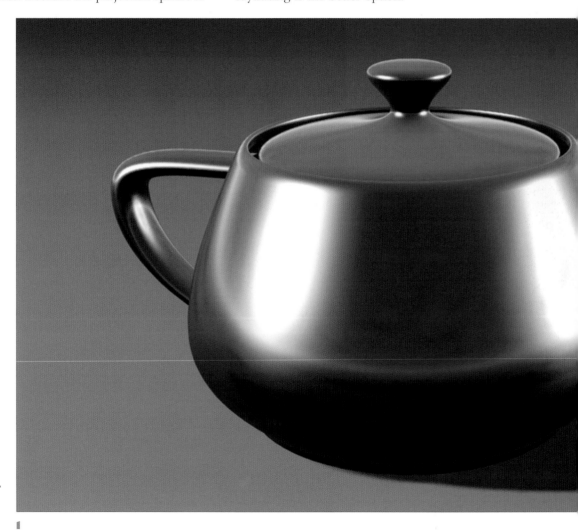

Here an environment image map has been used to simulate reflections on this teapot. Despite there being nothing else in this scene the object appears quite convincingly reflective, and it did not take long to render.

Light&Blue 360.img (RGB 1:1)

(819, 228):(157, 137, 138)

There are numerous ways in which to create environment maps. You can paint them yourself in Photoshop or to render a scene built specifically for this purpose in a 3D program using a QuickTime Panoramic render. By far the easiest way is to use photographs scanned into your computer (from an image CD or from the Web) that can be edited in Photoshop so that they work better as environment maps. The main reason for this is to remove the seams that occur as the image is wrapped around the projecting sphere.

Some programs, such as ElectricImage (*see page 19 and page 26*), generate environment maps from the 3D scene itself. It does this by rendering six images from the centre of the reflective object in six directions (top, bottom, front, back, left and right). These images are then re-applied as an environment map using a cubic projection. With a little bit of effort a similar effect can be achieved in most 3D programs, although the process is manually intensive.

2
This is the environment image map used to create the reflection. It is a landscape generated in a 360° panoramic image from another 3D program.

RENDERING

Rendering is one of the most confusing and misunderstood aspects of 3D computer graphics. There is so much misinformation, generalization and plain old untruths told by both users and companies that some effort should be made in this book to clarify the chaos.

The word rendering itself covers a wide gamut of uses, but for our purposes two broad categories can be defined. The first is interactive rendering – this encompasses all the rendering methods and technologies that display 3D imagery as quickly as possible to provide the viewer with feedback of the 3D information as instantly as possible. The shaded view in your 3D application or games console provides such 'display' rendering, which is (more often than not) hardware-accelerated. The other criterion for this heading is that the rendering is not, and often can't be, saved to a file but is jettisoned every time the image is re-drawn.

2
Final-quality rendering is produced by software. These images are saved to disk after completion and can take a while to produce. Pixar, the company that produced *Toy Story*, calculated that if a film was to be completed in a year, each frame should take, on average, two minutes to produce. Some final-quality hardware rendering systems are available, such as RenderDrive from ART, but they are rare.

1
The shaded view you see in your 3D application is displayed on the fly by your computer's 3D graphics card together with a rendering technology such as OpenGL.

3

3
The full motion video segments in today's games are pre-rendered movies and are a good example of final-quality rendering.

4
The 3D imagery you see when you play a computer game is drawn to the screen in real-time by sophisticated hardware. This is either a dedicated 3D graphics card in your computer or a games console.

4

The other category can be called final-quality rendering or (the often misused) photo-real rendering. This type of rendering is usually done by software alone for video, film or print. The goal here is quality (read: free from artefacts, such as shading errors, aliasing, flickering pixels, etc.) not interactivity, and the images generated are usually saved to disk as an image file. From these descriptions one of the first misunderstandings can be dispelled: that 3D graphics cards are anything to do with final rendering. They aren't. All that a top-of-the-line 3D workstation gets you is faster display rendering. It's up to the CPU (and memory and other subsystems) to provide the horsepower that propels a final render. That said, there are exceptions. Alias|Wavefront's Maya, for example, requires many of its particle effects to be saved using hardware rendering. In fact there's nothing inherent in OpenGL (or Direct3D, etc.) that says it can only be used for interactive display applications; it's simply that these technologies have been developed for such uses and are therefore optimized to do them. If you want the quickest 3D display you'll probably use hardware-accelerated OpenGL or Direct3D. If you want the highest-quality image from your 3D application with the least fuss, then it is best to use the software render engine that was specifically developed for that purpose.

RAYTRACING

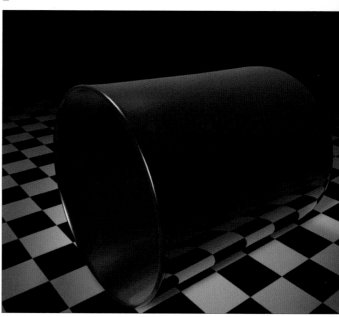

Over the years many methods have been devised that simulate the properties of light and materials in the quest to produce realistic imagery on the computer. Computers use these rendering algorithms to draw 3D objects that look convincingly real. The most intuitive approach is to have the computer simulate what happens to light in the real world using the physics of optics. This is the principle of raytracing, whereby individual rays of light are traced as they traverse the scene from the light source to the viewpoint. The initial problem with this 'forward raytracing', as it is known, is that many of the rays that leave a light source never actually end up at the viewpoint at all, but are scattered into the void. Having the computer calculate the paths of millions of never-to-be-seen light rays is computationally wasteful, but there is a useful alternative. Rather than starting the rays off at the light, it is better to start them

off at the point of view and follow them backwards (through each pixel of the image-to-be) to the light.

In raytracing all of the hard-to-fake optical properties we expect to see in a photo-real image naturally fall out of the technique, such as shadows, reflection and refraction. To calculate reflectivity, therefore, the initial primary ray generates a secondary ray when it hits a surface tagged as reflective. This second ray then bounces off in another direction until it either vanishes out of the scene (in which case the ray returns the scene background colour, assuming the object is 100 per cent reflective) or hits another object in the scene. If it hits an object it will obviously return that object's colour instead. Many programs have safety measures in place to stop highly recursive (or even infinite) ray generation occurring, usually in the form of a 'maximum ray depth setting'. The problem with raytracing is that it is computationally intensive and for very complex scenes is not really practical. This is because of the large number of primary rays that are needed to determine which faces in the scene are visible. Because raytracing is slow it is never used for interactive display rendering – that may change when CPUs get fast enough, though.

❙

In raytracing an imaginary ray of light is traced from the light source through the scene and back to the viewpoint. For a basic calculation one ray of light is traced for each pixel in the final image. This doesn't produce a very good image, however, and in order to get satisfactory quality many more light rays are traced.

2

This image of a glass has been rendered with no transparency or reflection. It's not at all glass-like, mostly because we expect to see a drinking glass that is transparent.

3

In this image we have enabled transparency and reflection. The glass has become more like what we expect to see in the real world, but it doesn't look entirely convincing.

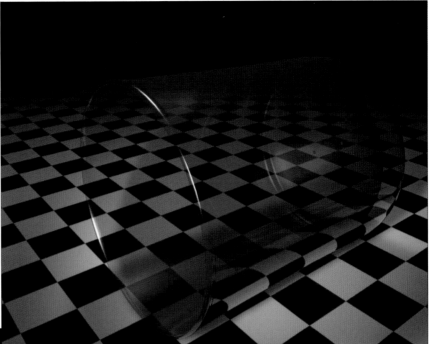

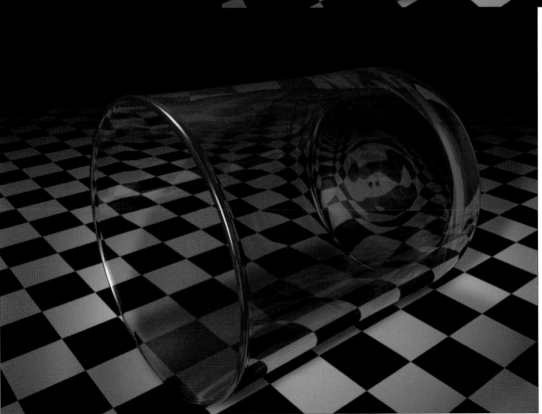

4

With refraction turned on, as well as transparency and reflection, the glass instantly looks much more credible. With refraction the thin walls of the glass bend the light slightly so that what you see through the glass is not what lies exactly behind it from the viewing direction.

SCANLINE RENDERING

The scanline approach to rendering applies a different method to those previously described. Rather than getting bogged down with total physical accuracy, it paints in the polygons using optimized shading algorithms (Lambert, Gouraud, Phong and Blinn, etc.). This type of rendering usually progresses one line of pixels at a time, hence the name scanline rendering.

After the renderer has depth sorted the scene, to find out which faces are visible and need to be shaded, these algorithms are used to literally fill in the polygons, taking into account the lighting and material definitions. Depth sorting may actually still be done using simplified raytracing, which is sometimes called raycasting because only the primary rays are used – one for each pixel. Alternatively a Z-Buffer sorting algorithm can be employed. This furnishes each polygon in the scene with a value, depending on its distance from the camera. If a given pixel contains overlapping polygons in its line of sight, then their values are read, and only the polygon with the highest Z-Buffer value (the closest to the camera) is shaded. The result of all these technical shenanigans is that rendering times are vastly reduced, especially when compared to raytracing.

The problem with the scanline rendering method is that effects such as reflection, refraction and shadows are not calculated automatically. It is possible to simulate reflection and shadow casting using special tricks, but a refraction effect can be much more difficult to achieve with a fake.

Therefore many renderers employ a hybrid of scanline rendering and raytracing. In this case raytracing is evoked only for pixels that contain reflective or refractive polygons. In this way you seem to be able to get the best of both worlds.

Reflectivity is easily faked by using environmental image maps, and shadows can also be easily and quickly produced by rendering a special greyscale

The scanline renderer progresses one line of pixels at a time, displayed here with a white line.

image from the point of view of the light to determine occlusion (and therefore determine where the shadows are). Many experienced 3D artists as well as novices make the mistake of assuming that a raytracer is inherently better than a scanline-based renderer. This is a huge mistake to make.

It usually requires only a small amount of extra set-up and effort by an artist to get a scanline renderer to produce photo-real shadows and reflections and the time-saving when raytracing means it is almost always worthwhile. In fact the most prolific, and arguably the best, commercial rendering engine in use today does not raytrace. Pixar's Photorealistic RenderMan, used to produce the majority of 3D-rendered imagery you see in feature films, is very, very quick and produces stunning images, but it does not raytrace.

2
This is what a
depth map looks
like. It was rendered
automatically by the
software from the
light casting the
shadow.

3
This is the image
using the depth-
map shadow.

RADIOSITY

Radiosity is a technique that attempts physical accuracy with regard to lighting. Its purpose is to describe the energy distribution in a scene by effectively making every object a potential light source. In the real world, when light strikes an object, part of the light is absorbed and the rest is reflected back into the environment. This reflected light carries on through the scene, striking other objects until its energy has been completely absorbed (possibly ending its passage at your retina, which results in you seeing the object). This is why light streaming into a window illuminates not only the opposite wall, but under and between objects and into corners. It's not the direct light that is doing this, but rather the reflected light from walls and objects in the room.

It is reflected light that radiosity simulates. Radiosity describes the reflected light distribution in a scene and then usually another rendering method, often raytracing, is used to actually render the image, taking into account the radiosity information. There are a few methods for achieving this, but generally they all require a great deal of computation time, much more so than standard raytracing. The technological details of the different radiosity methods are beyond the scope of this book, but the examples shown here will help to demonstrate the effect that a radiosity calculation will have on a 3D scene.

1
The raytraced image is provided for reference. Notice that it lacks the lighting detail and naturalness of the radiosity render. An area outside the cone of the spotlight's direct illumination remains black.

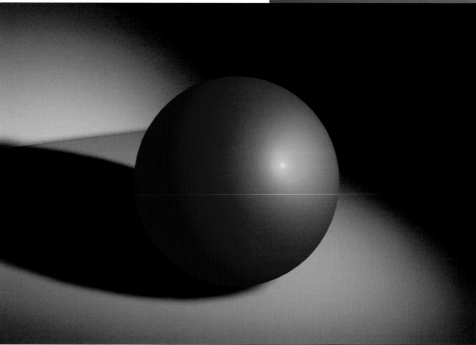

1

2

Adaptive radiosity calculates the effect of bounced light radiation in a scene between objects, but is much quicker than the full radiosity method. Notice the colour of the red sphere bleeding onto the floor and the way that the shadow is not totally black in some areas but is illuminated by reflected light from nearby surfaces. A single spotlight is all that is used to light the scene.

3

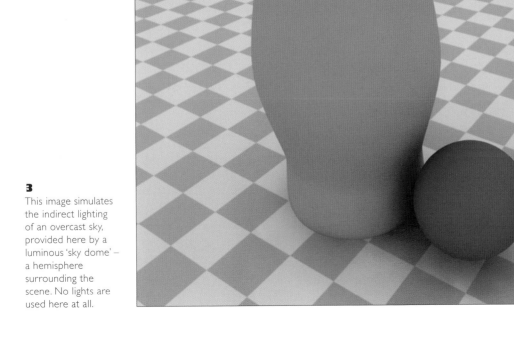

3

This image simulates the indirect lighting of an overcast sky, provided here by a luminous 'sky dome' – a hemisphere surrounding the scene. No lights are used here at all.

MODELLING • 96

TESSELLATION • 98

PARAMETRIC OBJECTS • 100

SURFACES VERSUS SOLIDS • 102

CREATING A PISTON USING SOLID MODELLING • 104

PRIMITIVE MODELLING • 108

BOOLEANS • 110

ECONOMICAL MODELLING • 114

DETAIL • 118

THE IMPORTANCE OF EDGES • 126

ANIMATION • 128

KEYFRAME ANIMATION • 132

ANIMATING JOINTED HIERARCHIES • 136

ANIMATING SINGLE-SKIN CHARACTERS • 138

ANIMATION GUIDELINES • 142

UV TEXTURE MAPPING • 146

GENERATING UVS FOR POLYGON OBJECTS • 150

MODELLING

earning 3D digital design is fun. It's difficult at times, but incredibly rewarding in the end. So what better way to learn about the tips and tricks of applied 3D computer graphics than with some hands-on examples? In this section we'll look at the basics first, explore the more advanced possibilities and then examine the difficulties that you might encounter day-to-day when producing 3D work.

There are many different technologies for creating 3D objects, the most simple and straightforward of these being the polygon. This is the simplest type of geometry in 3D graphics. It is flexible, robust and easy to render but not without its limitations. NURBS are special mathematically defined surfaces that are constructed from a net of curves. Unlike polygons, they can represent smooth surfaces without requiring hundreds of points, but are quite inflexible in their surface structure and therefore require a specialized toolset.

1
A mesh of connected points forms the polygon object's surface. On the left is a polygon object constructed from myriad polygons that only approximate the curved surface. Polygons are flat, so using them to define any curved surface is like trying to draw a circle using straight lines. On the right is a NURBS object that uses mathematical equations to define the surface, which results in a smooth, accurate model. The purple lines are called hulls and link the NURBS control points to provide a visual clue to the way the points are linked up.

1

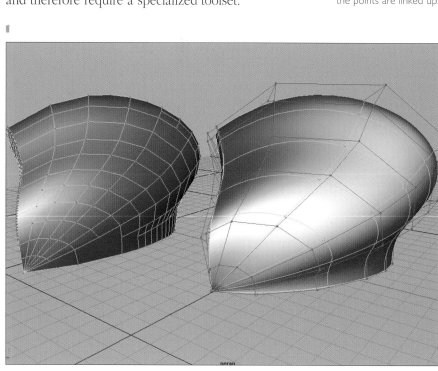

persp

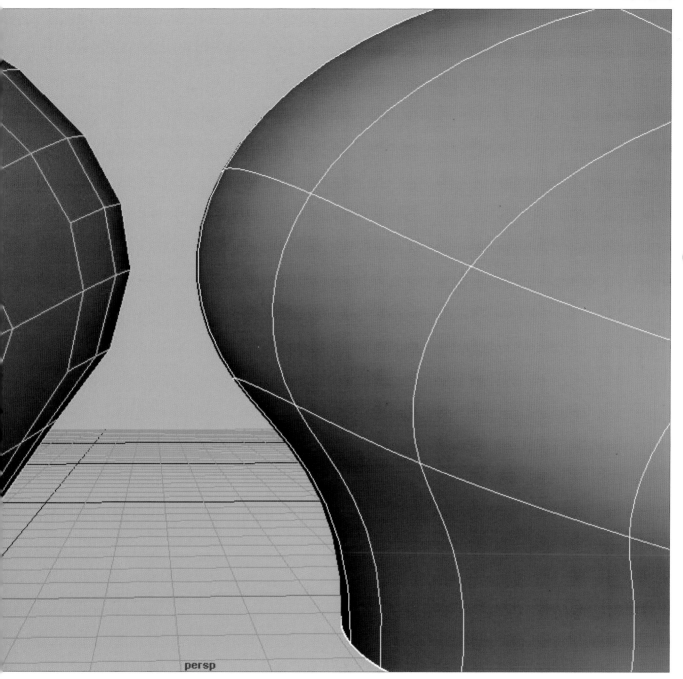

persp

2
Close inspection of the two surfaces reveals their differences. The polygon surface on the left looks choppy in profile because of the flat nature of polygons. The NURBS object, however, appears smooth, no matter how close we get to it.

TESSELLATION

To display NURBS surfaces as lit and shaded objects, 3D programs would have to tessellate them first. Tessellation means 'to tile', so it's the approximation of a surface using polygon 'tiles', usually triangles. Unlike a simple polygon object, a NURBS surface can have its tessellated resolution changed on the fly. So as you work you may have a lower tessellation, giving you a good but rough feedback of the curvature of the surface, enough for constructing the scene or animating, but the tessellation can be made much finer when the surfaces are rendered.

A benefit of tessellating NURBS surfaces in order to render them is that it can be done dynamically, depending on the surfaces' distance from the camera. If the object is far away it doesn't require so many polygons to look okay, but as you approach it the tessellation can increase, so that even if you zoom right into the surface you'll never see a facet. The corollary to this is that dynamically tessellated objects minimize system resources during rendering, particularly memory requirements, because the further away they are, the less data is required in their construction.

Imagine a fleet of spacecraft, perhaps a hundred or more, flying through space. The camera follows the group, skirting its outer edge, until it finally flies off into the distance. If NURBS are used to construct the ship model, dynamic tessellation means that the ships close to the camera will be highly tessellated, ships in the mid-distance will have a medium tessellation, while the most distant (the majority) will have a low tessellation. You will save time making this imagery using tessellations because you won't have to build three separate models of different resolution, or have the hassle of making sure the right models are in the right places at the right time.

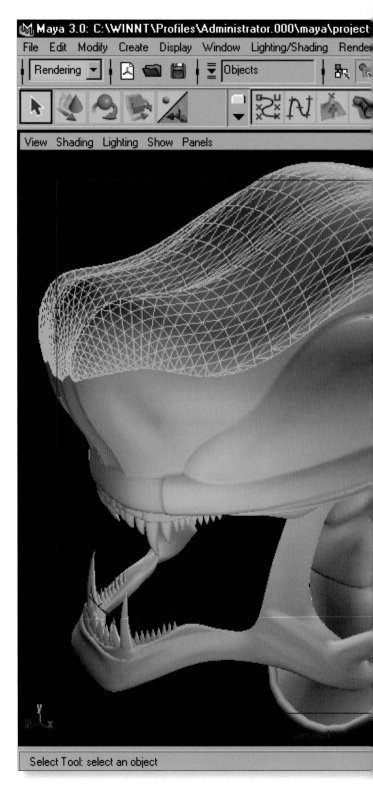

ut\AlienNOT2.mb --- HeadTopTrim

ects Fur Help

List Selected Copy Focus Attributes

HeadTopTrim2trimmedSurfaceShape | HeadTopTrim2trimmedSurfaceShap ◄ ►

nurbsSurface: HeadTopTrim2trimmedSurfaceS Focus

NURBS Surface History

Min Max Range U	0.000	6.000
Min Max Range V	0.000	16.000
Spans UV	9	16
Degree UV	3	3
Form U	Open	
Form V	Open	

► Components

► NURBS Surface Display

▼ Tessellation

☑ Display Render Tessellation
(in Hardware Shading Mode)

Refresh Screen Space

Triangle Count	5025
Min No. of Triangles	6048

Curvature Tolerance	Highest Quality	
U Divisions Factor	2.000	
V Divisions Factor	2.000	

☑ Smooth Edge
Smooth Edge Ratio 0.990
☐ Edge Swap

► Explicit Tessellation Attributes

Select Load Attributes

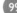
NURBS surfaces are
tessellated into
polygons for display
and rendering. The
polygons are only an
approximation of the
true NURBS surface,
but the resolution of
the tessellation can
be as fine as you like,
down to the sub-pixel
level if you wish, but
for any given image
it produces the
appearance of a
perfect surface. Most
of the time sub-pixel
tessellation is not
necessary as the
polygons here are
quite large, but
the object is well
described by them.
Note that triangles
are used for the
tessellation. This is
because triangles
can never be bent
or ill-formed like
quadrangles or other
polygons, so they will
render perfectly.

PARAMETRIC OBJECTS

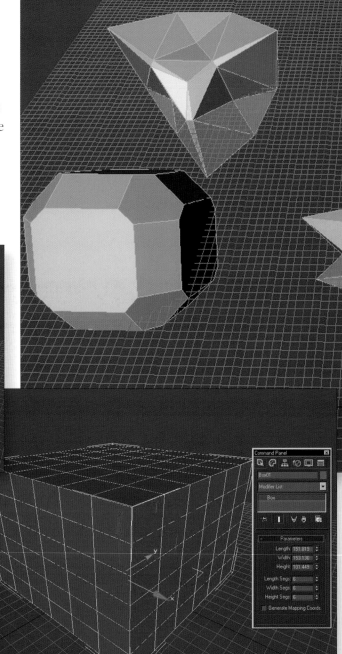

Perspective

Parametric objects are another geometry type. Well, they are not strictly a type of geometry in the same way that polygons or NURBS are; rather they are a way of creating geometry and maintaining control over the parameters. Parametric models are like mini-programs or mathematical formulae that create 2D and 3D objects within the host 3D program. The objects that they create could be made of polygons, NURBS or any other sort of geometry, but what is unique about parametric models is that the parameters can be edited to change the resulting object's shape. This is similar in a way to construction history, except that with a parametric

Perspective

1
The parametric cube object above has not had any changes made to its basic shape.

2
By accessing the cube's parameters you can modify them to, for example, increase the number of polygons used to make it up. This is useful because you may want to deform the object and so will need a higher resolution to keep the deformation smooth.

object all the input parameters are already supplied and cannot be changed. For example, a parametric sphere may have controls for radius but also for sweep, allowing you to create a hemisphere or segment. A parametric cube may have controls for the number of subdivisions each face has, or whether or not the edges are to be rounded.

Parametric objects do vary from program to program because the number of parameters given to a parametric object and the output geometry type is totally up to the programmers. They may even provide you with a choice of geometry.

It is usually possible to convert a parametric object into standard geometry, say a polygon cube or sphere, thereby losing all the input parameters that can change its shape. This may be necessary in order to edit the object on a component level – for example, to edit the surface CVs if it is a NURBS object, trim it or add or subtract surface isoparms and project curves onto it.

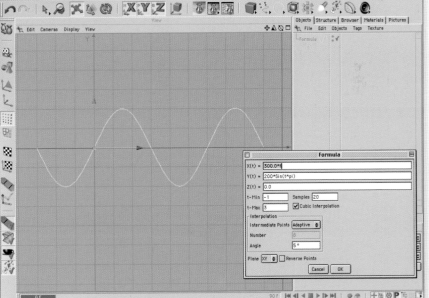

3
These four shapes have been created from the same parametric Primitive. Simply by changing the settings you can arrive at totally different shapes, though the amount of variability depends on the parameters that are offered by the Primitive.

4
Another way to generate 3D surfaces, is by using formulae. An option offered in some 3D programs is almost like creating your own parametric Primitives using mathematical functions. Here a sinusoidal curve has been created using a formula entered into the object's parameter control panel.

SURFACES VERSUS SOLIDS

So far we've looked at 3D objects that can be constructed from surfaces, such as nets of either polygons or NURBS curves. A flat NURBS plane has two sides, like a piece of paper, and if you curl the surface in both axes to form a sphere you still have two sides, it's just that one is inside and the other outside. A sphere created from NURBS or polygons in this way is hollow, because it's simply a surface surrounding a region of 3D space.

Another way to represent closed volumes is by using parametric objects called Solids. Solid objects do not have two sides and they can never be open. In other words, they always enclose a volume, no matter what their actual shape is. While there's no way to unwrap a Solid, there are special cases, such as infinite planes, which are open but still one-sided.

The other aspect of Solids is that they have no control points – their surface is entirely analytically defined. That means that you can't sculpt them in the same way as you can a surface with points, but it also means that the object's resolution is infinitely fine. You can slice and dice a Solid as much as you like, with no degradation or risk of the object falling to pieces.

Solids are particularly well suited to industrial modelling tasks such as CAD/CAM and product visualization. This is why many of the packages geared towards these fields feature Solid geometry engines at their core. NURBS

technology is also used in these programs since you'll need to be able to create open surfaces such as car body panels. Programs that combine surfaces and solids have a problem, though. Because of the inherent differences in the geometry types there needs to be tools for each. This can make it confusing, since it's not always obvious if a given object is a Solid or surface. There are exceptions – ElectricImage Universe features a hybrid surface/solid modelling environment, but also a common toolset.

2
Here is a Solid before we attack it with a Knife tool. A Knife is exactly like its real world counterpart, though maybe cheese wire is a more appropriate comparison. There are Knife tools available that are circular or square, and ones that even use a curve.

1
If you take a Solid sphere and a Surface sphere and then cut them down the middle, you get two different kinds of objects. It is the same as cutting a football and a ball of cheese in half: one is hollow and the other is not. The football has two sides, but the cheese has only one side, its outside. You can replicate most solid objects using surfaces, but you cannot represent an open surface using Solids.

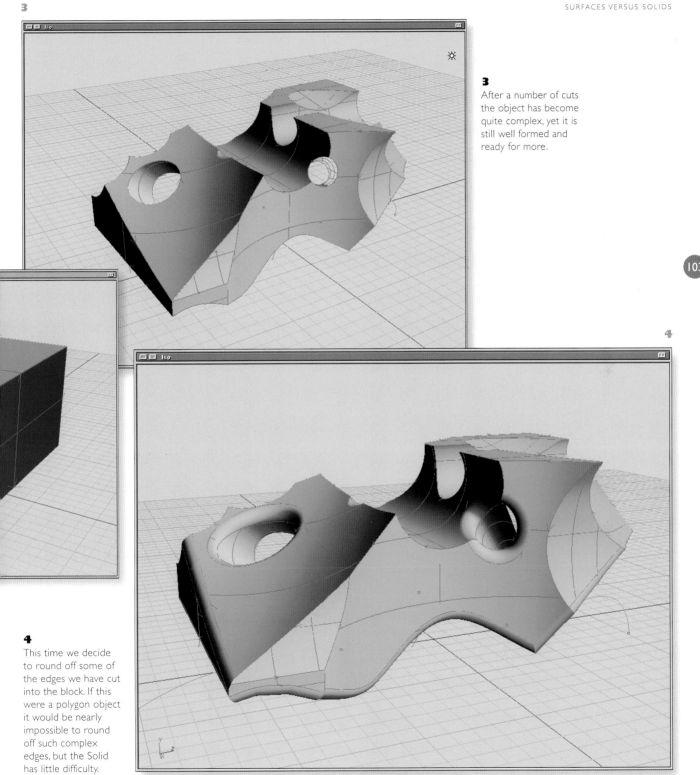

3
After a number of cuts
the object has become
quite complex, yet it is
still well formed and
ready for more.

4
This time we decide
to round off some of
the edges we have cut
into the block. If this
were a polygon object
it would be nearly
impossible to round
off such complex
edges, but the Solid
has little difficulty.

CREATING A PISTON USING SOLID MODELLING

The best way to show Solid modelling is by demonstration. In this example we will create a mechanical part, a piston, using the Solid modelling in ElectricImage Modeler, a robust application that uses the renowned ACIS geometry kernel from Spatial Corporation.

1

We begin with a Solid Cylinder Primitive, which is duplicated and scaled down slightly. This is positioned so that it protrudes from the base of the larger cylinder, ready for a Boolean Subtraction (*see pages 110–13 for an explanation of this*).

2

With the Boolean Subtract tool active, the larger cylinder is selected, then the smaller one and finally we double-click to perform the action.

2

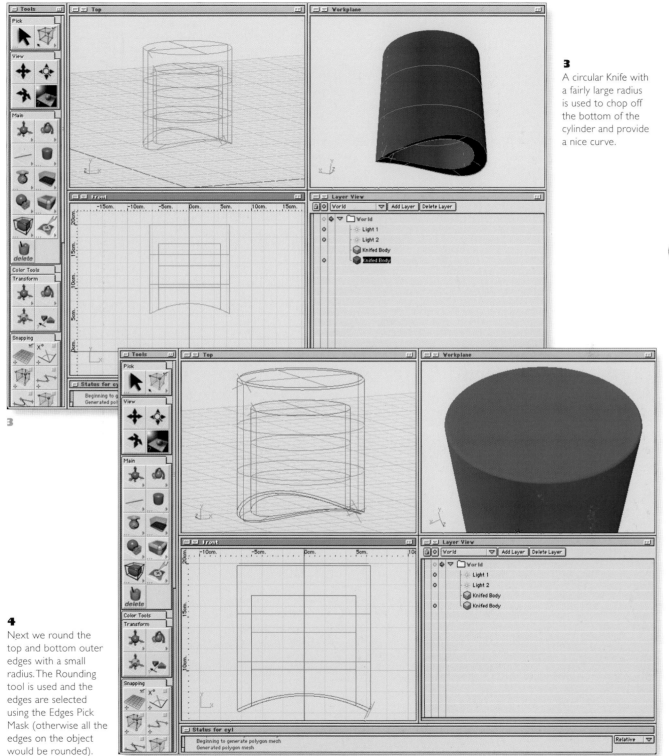

3
A circular Knife with a fairly large radius is used to chop off the bottom of the cylinder and provide a nice curve.

4
Next we round the top and bottom outer edges with a small radius. The Rounding tool is used and the edges are selected using the Edges Pick Mask (otherwise all the edges on the object would be rounded).

5

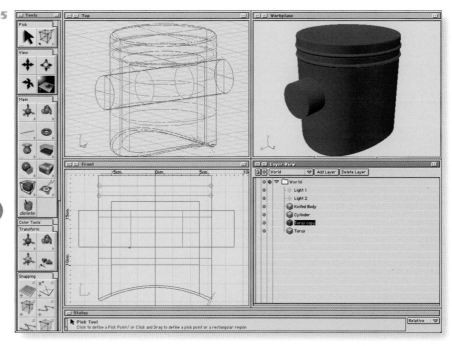

5

Next three more objects were created – another cylinder and two toruses. The new cylinder was positioned to intersect the old one at its centre and the toruses were created with a primary radius (ring) just slightly smaller than the main cylinder and with a very small secondary radius (the pipe radius).
(The second torus is just a duplicate of the first one.)

6

The three new objects are duplicated and grouped into a new layer and hidden, then another Boolean Subtract is used.
The main cylinder is picked first, then each subsequent object is picked (one each of the ungrouped toruses and cylinder) and designated as the subtraction objects. Here's the result of the subtraction.

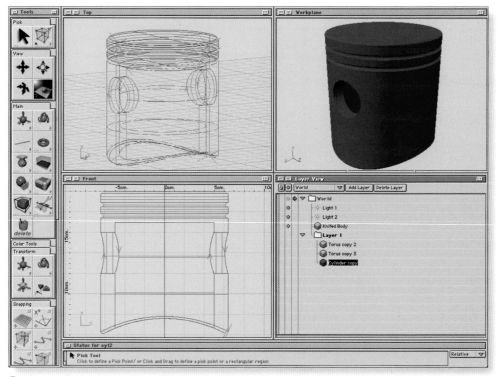

6

7

The duplicated subtraction objects are unhidden (the cylinder is cut down by knifing each end) and scaled down slightly as if they fitted in the subtracted areas perfectly. We could have scaled the cylinder along its length, but the version of ElectricImage Modeler we used did not support non-uniform scaling at that time.

8

The rest of the piston was modelled in a similar fashion using Boolean Union and knifing to form the shaft. It was then all rounded to blend the parts together.

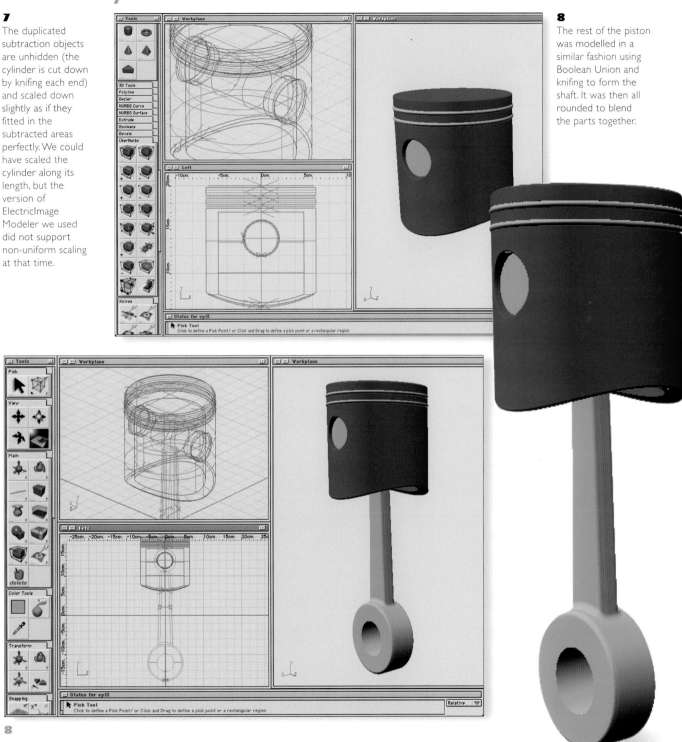

PRIMITIVE MODELLING

As 3D programs provide you with a bunch of Primitive objects, simply assembling them in the right combinations is the easiest way to model. Of course primitive modelling does have its limitations, so it is only really suited for simple objects that do not require a lot of realism.

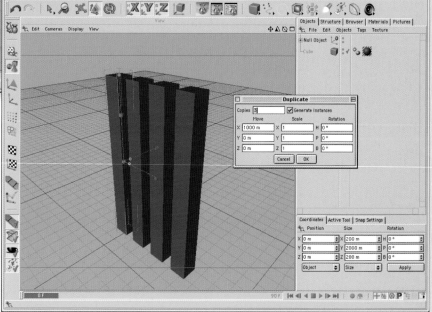

3

To create four legs you can either duplicate the cube or copy and paste it three times. The best option is to create instances of the cube. An instance is a reference to the original object, not a complete copy, using the duplicate modelling function in XL. If you change the original, the instances change too, but you can also move, distort or change the instances independently.

1|2

The simplest modelling procedure uses Primitives to build an object, which in this case is a table. We begin with a cube using Cinema 4D XL from Maxon Computer, then scale it in the y axis to form a table leg. To scale an object you can use a Scale tool and drag on one of the on-screen transform gizoms, or you can deactivate the z and x axes and drag anywhere. For precise scaling you can enter a scale value in the objects' numeric coordinates panel.

3

4

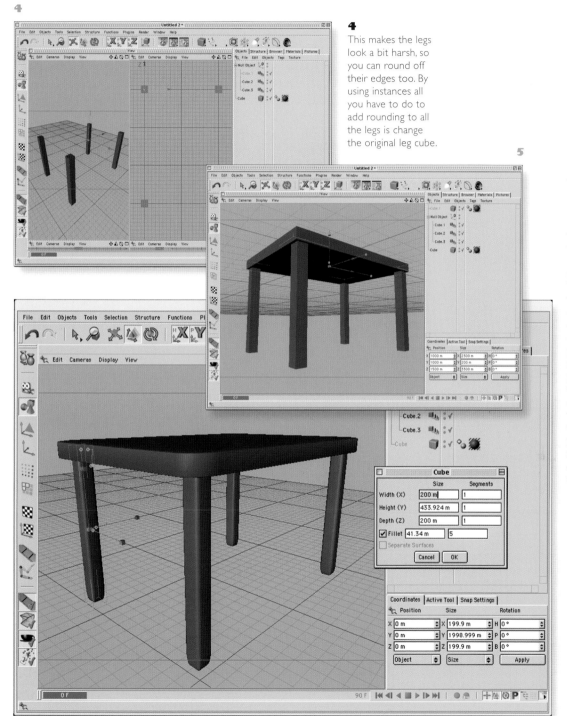

4
This makes the legs
look a bit harsh, so
you can round off
their edges too. By
using instances all
you have to do to
add rounding to all
the legs is change
the original leg cube.

5

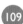

5 | 6
The table top is
added, which is
another cube. It is
scaled in z and x so
that it just overlaps
the legs and is
positioned so that it
sits on top of them.
We decided that our
table top would look
better with rounded
edges, and because
our cubes are
parametric Primitives
rather than just
polygons or NURBS,
we could access the
cubes' parameters
to add the rounding,
without having to
perform a complicated
modelling procedure
or rebuilding the top
from scratch.

6

BOOLEANS

Boolean modelling is a technique that uses objects as cutting tools. You can use Booleans to subtract one shape from another, to unify two shapes or to intersect two shapes. It's similar to adding, subtracting and intersecting selections in Photoshop, except that it obviously occurs in 3D.

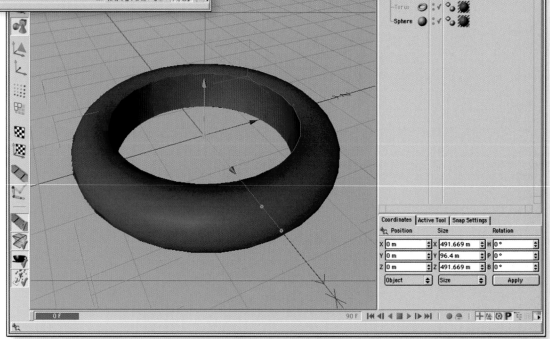

1 | 2 | 3
Here is a simple Boolean modelling operation. A sphere and torus are added to the scene and the torus is positioned so that it intersects the sphere at its equator (1). With the Boolean tool set to Subtract, the torus removes a part of the sphere, leaving the part that was intersecting it behind (2). If you change the order of the operation, you get the opposite: the sphere is subtracted from the torus (3).

1

2

3

4
An option in some programs is to cut the surfaces rather than subtract them. In this case the torus cuts away part of the sphere, as before, but does not leave its imprint in the surface.

5
Intersecting the two objects produces an object that is made of only the parts of the two objects that overlapped – i.e. where they intersect each other in 3D.

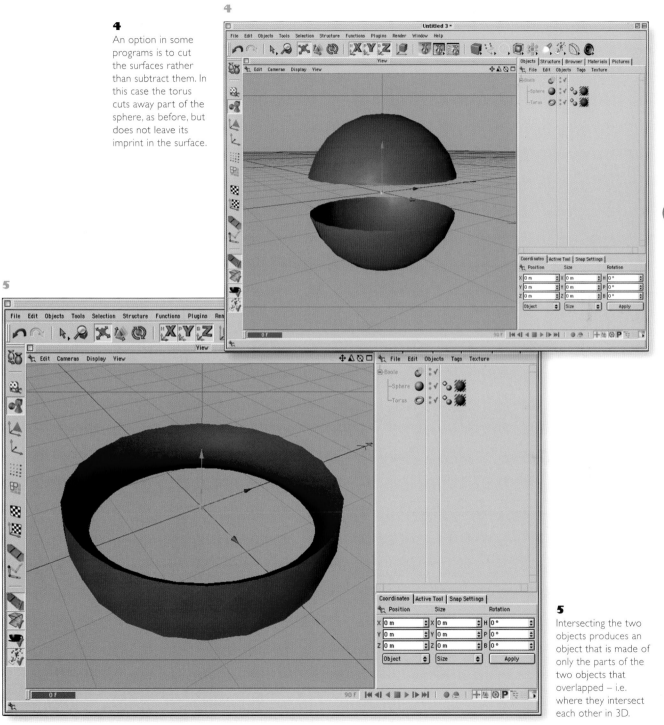

6

6
A Boolean intersection creates an object that is equal to the portions of the two objects that overlapped. The order of the objects is not important in this case. Intersections can be used to create interesting compound objects like the one shown here, which is formed by a cone and a capsule.

7
Booleans are usually created between polygon objects, though NURBS can be Booleaned too. The problem with Booleans is that where the two objects intersect, the edges produced are liable to artefacting, especially if the objects aren't made up of enough polygons in the first place.

7

8
By increasing the resolutions of the Boolean objects, the edges are much cleaner and artefact-free. The disadvantage is that you end up with much denser objects, but in many circumstances this is a small price to pay because Boolean objects can be fiendishly difficult to re-create any other way.

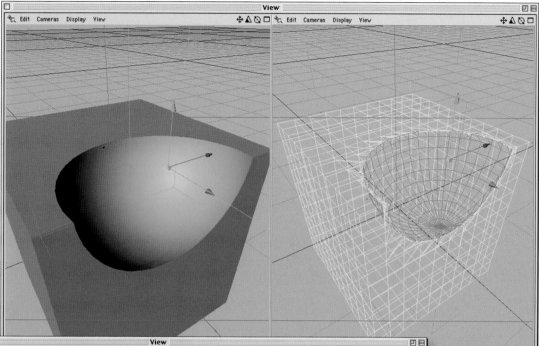

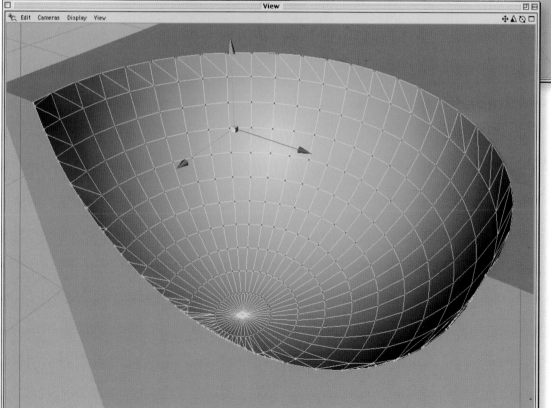

9
Another problem with polygonal Booleans is that they result in edges that are, frankly, a mess. Though they look fine rendered, the sheer amount of points along Boolean edges means that it is difficult to do anything with them afterwards.

ECONOMICAL MODELLING 1

1

1
When planning an animation it can be a good idea to make a few sketches that lay out the action and camera angles. These drawings are called storyboards.

2
A storyboard doesn't have to be well drawn, like this one, it just needs to provide you with a plan of attack. Usually the mere act of producing a storyboard forces you to plan each shot.

When modelling objects that will eventually be used in an animation, it is always best to make a plan so that you know what will be seen in the final animation, and therefore what you need to model to get the desired result. Creating a storyboard is a very good idea. A storyboard is a series of sketches that depict key moments in an animation. What a storyboard will also contain is a rough guide to the camera positions and directions so that at each important moment you get a good idea of what will be in shot and what will not. The golden rule of modelling should be adhered to at all times: only model what will actually be visible in the animation.

2

3

3

When you draw a storyboard you may find that a particular sequence or event doesn't seem to work or fit. Discovering these problems at the pen-and-paper stage will save you a lot of heartache later on.

4

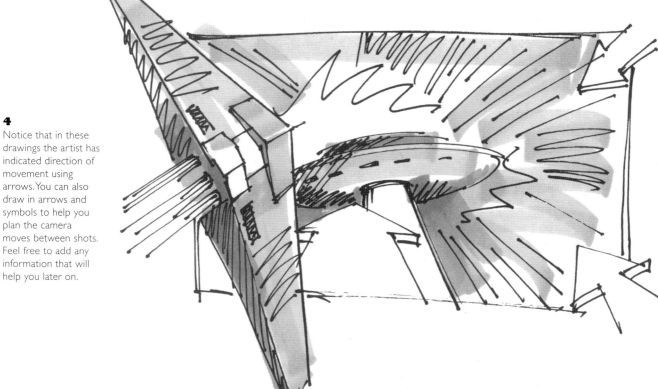

4

Notice that in these drawings the artist has indicated direction of movement using arrows. You can also draw in arrows and symbols to help you plan the camera moves between shots. Feel free to add any information that will help you later on.

ECONOMICAL MODELLING 2

Try not to get so carried away with a particular object that you start adding in details that will never be seen. For example, the object's rear side never sees the camera, so you should not spend any time modelling it.

A similar rule applies to distant or insignificant objects in a scene. If a particular object is very distant or insignificant, then you can get away with making the model extremely simple – even just an impression or sketch will do. Much of the detail can be implied using textures anyway.

3

2

1 | 2 | 3 | 4 | 5
This animation sequence is very simple (like the model). The camera moves from a longshot to a close up on the front door. We could have added some more detail to the door since it would be the prime focus of the shot and the rest of the house can be well built and textured too.

1

4

5

6

6
It's a very simple model, but we spent no time at all on the back of the house since we knew it would never be seen. Planning a storyboard will also prevent you from having to re-create the back of the house if, in a later scene, it will be in shot. In that case you'll save time by modelling the whole thing at the start.

DETAIL

3D graphics is all about making decisions. When you come to model an object, depending on its end use, you will decide how detailed you want it to be. Even simple models can end up being complex if they are going to be examined in detail, so how close the object will be to the camera in the final image will be a major factor in your model-making decisions. The other factor to consider is style, so if hyper-realism is your goal, then your models will need to be detailed. However, if you want a lo-fi look then you can use simple models.

In the following steps we've taken a familiar and deceptively simple object, a snooker cue, and tackled its modelling in three different ways. The modelling lesson is divided up into three detail sections – low detail, medium detail and high detail.

1
Low detail. In the first example we need a very simple model of the cue made, because it will be used in a computer game. We added a polygon cylinder Primitive to the scene, with eight sides and no divisions along its length. We also made sure it had caps.

2
If we wanted to be really picky, we could delete the eight triangles that composed each cap and replace them with a single eight-sided polygon. As we were not that fussy we just carried on modelling. To create the cue we selected the points that made up one of the ends of the cylinder and scaled them uniformly.

3

Once we got that far we could have decided that the cue was too short. As the points were still selected, we could move them in the negative x direction to make it longer and skinnier.

4

And that's it finished. In the context of the other models, a snooker ball and table, the model is sufficient for its intended purpose.

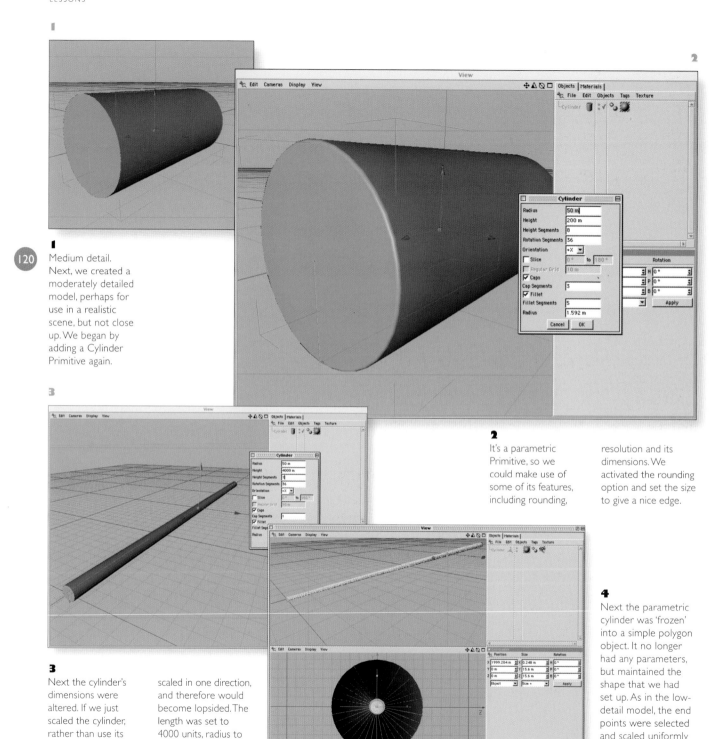

1

120

1 Medium detail. Next, we created a moderately detailed model, perhaps for use in a realistic scene, but not close up. We began by adding a Cylinder Primitive again.

2 It's a parametric Primitive, so we could make use of some of its features, including rounding, resolution and its dimensions. We activated the rounding option and set the size to give a nice edge.

3 Next the cylinder's dimensions were altered. If we just scaled the cylinder, rather than use its parameters, the round would also become scaled in one direction, and therefore would become lopsided. The length was set to 4000 units, radius to 50 units and the length segments set to 1.

4 Next the parametric cylinder was 'frozen' into a simple polygon object. It no longer had any parameters, but maintained the shape that we had set up. As in the low-detail model, the end points were selected and scaled uniformly in order to create the pointed end.

5

6

6
The tip was added to the cue as a separate object to facilitate texturing later on. The end was rounded and the whole thing closely butted against the end of the cue. The ends were not overlapped, so that the rounds on the cue would still be visible, as they might catch some nice highlights in the final render.

5
A polygon cube was used as a cutting tool to remove a portion of the thick end of the cue, to create the detail you usually see on snooker cues. This was done with a Boolean subtraction operation.

8

8
Next the texture map for the tip was created in Photoshop and applied to the tip model.

9
Here is the finished render of the cue. It is moderately detailed and will look good in most situations, so long as there is not an extreme close-up shot.

7

7
Colour and reflection image maps were created in Photoshop to make the material for the tip object. This is the reflection image used. Where the image is black the surface will not be reflective, where it is white (for the metallic part of the tip) it will be reflective.

9

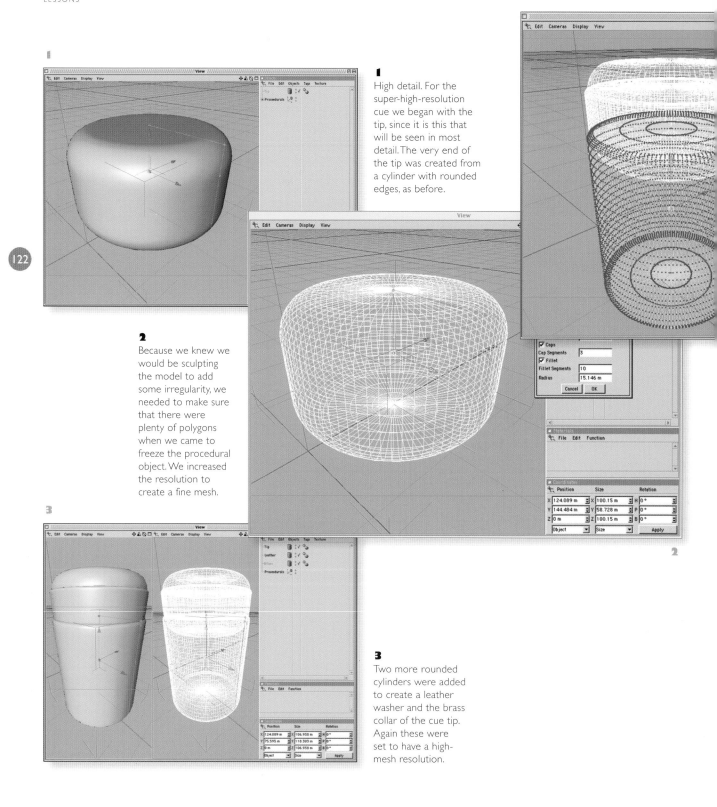

1

High detail. For the super-high-resolution cue we began with the tip, since it is this that will be seen in most detail. The very end of the tip was created from a cylinder with rounded edges, as before.

2

Because we knew we would be sculpting the model to add some irregularity, we needed to make sure that there were plenty of polygons when we came to freeze the procedural object. We increased the resolution to create a fine mesh.

3

Two more rounded cylinders were added to create a leather washer and the brass collar of the cue tip. Again these were set to have a high-mesh resolution.

4

5

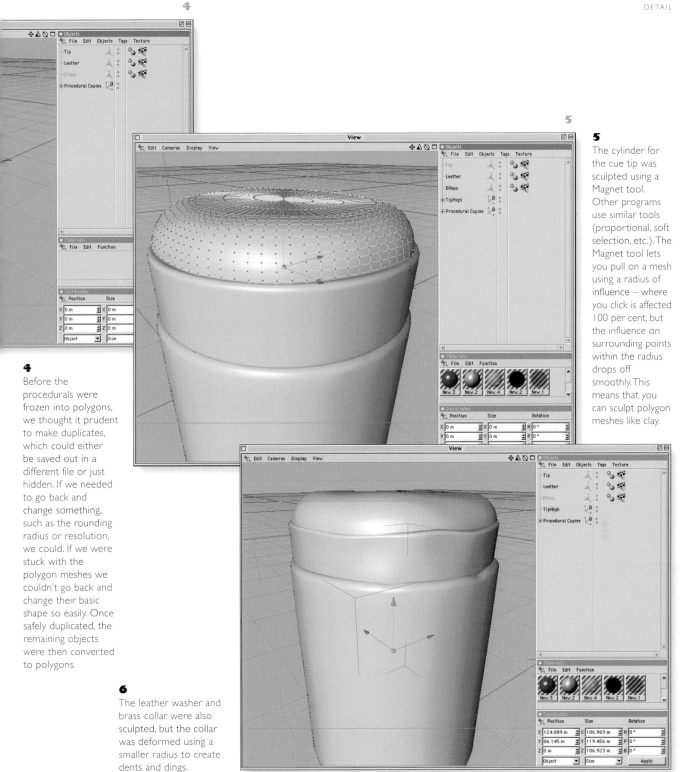

5

The cylinder for the cue tip was sculpted using a Magnet tool. Other programs use similar tools (proportional, soft selection, etc.). The Magnet tool lets you pull on a mesh using a radius of influence – where you click is affected 100 per cent, but the influence on surrounding points within the radius drops off smoothly. This means that you can sculpt polygon meshes like clay.

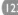
123

4

Before the procedurals were frozen into polygons, we thought it prudent to make duplicates, which could either be saved out in a different file or just hidden. If we needed to go back and change something, such as the rounding radius or resolution, we could. If we were stuck with the polygon meshes we couldn't go back and change their basic shape so easily. Once safely duplicated, the remaining objects were then converted to polygons.

6

The leather washer and brass collar were also sculpted, but the collar was deformed using a smaller radius to create dents and dings.

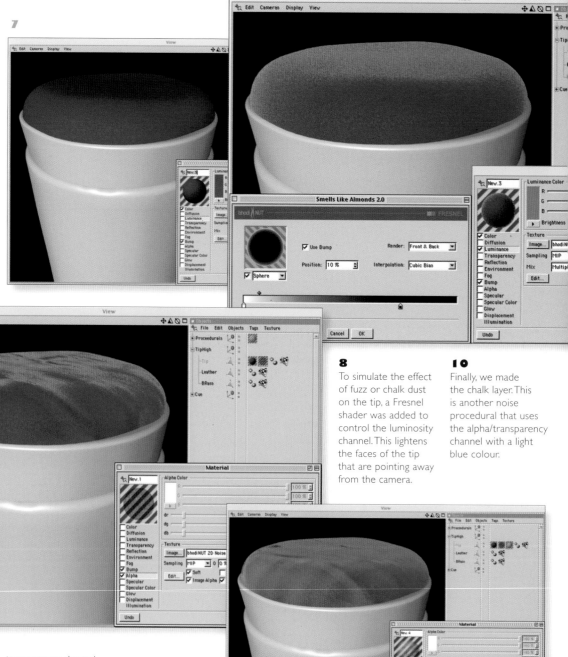

7

Unlike the medium-resolution cue, this tip is in three sections so must be textured separately. The tip incorporated the technique of layering multiple textures and was actually created with procedural shaders rather than bitmaps. The first layer is a simple layer of noise, in both the colour and bump channels of its material.

8

To simulate the effect of fuzz or chalk dust on the tip, a Fresnel shader was added to control the luminosity channel. This lightens the faces of the tip that are pointing away from the camera.

9

The next layer is the scuff layer. This is another noise procedural, but is used in the alpha channel of the texture (in most programs the transparency channel will work too). The colour of the layer is black so that we could get the effect of wear and tear on the tip.

10

Finally, we made the chalk layer. This is another noise procedural that uses the alpha/transparency channel with a light blue colour.

11

The other two
sections were
textured using the
same technique of
layering textures.
Fresnel shaders are
a big help when re-
creating materials at
small scales, since
they can suggest the
fuzzy edges you see
on small organic
surfaces such as
fabric, suede, etc. A
Fresnel shader was
also used to control
the reflection from
the brass collar. Here
is the finished cue
tip, ready to be
rendered up close.

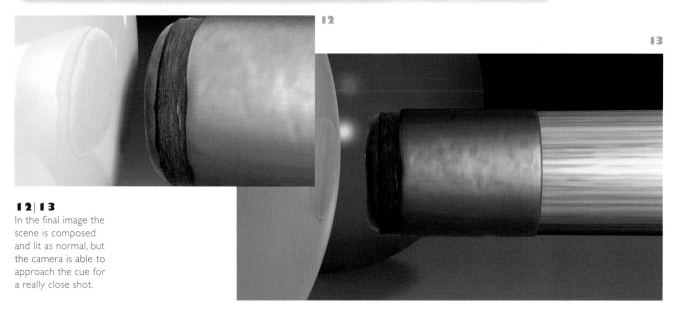

12

13

12 | 13

In the final image the
scene is composed
and lit as normal, but
the camera is able to
approach the cue for
a really close shot.

THE IMPORTANCE OF EDGES

Edges are very important – not only the edges of each polygon, but the edges that define the form of an object. They set the limits of objects, their profiles and separate areas of shading. Many modellers don't think about modelling the edges of an object because they are a direct result of the modelling process, so the modellers believe they don't have to create them manually. Real objects do not have infinitely sharp edges; they are blunt, rounded-off or chamfered. This softening of edges makes your 3D objects look more realistic. Edges catch highlights (or darkness) to help separate adjoining faces with a definite line. Consider the following example.

1
Here is a simple 3D icon. It looks fine, but in places the edges don't separate the areas of similar shading too well, which results in the form being hidden in places.

2

3
Here is a close-up
of the bevelled edge.
Notice how the bevel
catches highlights and
clearly separates the
front and sides of
the object.

2
Now look at this image.
See the difference? All
we have done is added
a tiny bevel to the edges
of the extruded object.

ANIMATION 1

In 3D computer graphics animation is the production of a sequence of images that shows an event that changes over time. It may be simply a ball bouncing, an army of robots fighting a pitched battle, a herd of dinosaurs romping across the Jurassic countryside, or anything else that can be imagined.

Each image represents a frame, the simplest whole division of time in the world of 3D animation. The term 'frame' comes from film and broadcast, where the 'real-time' images you see on screen are merely single snapshots of time that are played one after another in sequence. They seem to merge into one continuous time stream because of two particular quirks of the human eye/brain system called 'the persistence of vision' and 'the phi phenomenon'. Basically you retain a 'memory' of an image for a few moments after you've experienced it, so that a staccato sequence of still images blends together to give the impression of smooth movement. The human brain is also quite good at interpolating missing information, especially from closely spaced events, filling in the blanks as it were to re-create what it expects it should be seeing.

The persistence of vision and the phi phenomenon are the reasons why simple devices such as the zoetrope succeed in creating moving images so easily.

In the world of film, each second in actual time is represented by 24 frames. So

1

A zoetrope works by rotating a sequence of images which form an animated sequence when viewed. The machine works on the same principle as film and television by producing a series of still images in quick succession.

1

128

2
The two fields in the image are of two slightly different points in time in this animation. You can see the position of the tower is different in the two fields.

3
When motion is too quick to be captured by the shutter of a camera you get motion blur. This is a natural effect in both human visual systems and cameras. Motion blur in video systems often looks different to film blur because of the fields nature of video and the higher frame rate.

film is said to be '24 frames-per-second' or 24 fps. In broadcasting there is more than one standard, depending upon which part of the world you live in. In Europe the broadcast system is PAL, while in Japan, the United States and Canada it is NTSC. In other parts of the world including the former USSR and parts of Africa, it is SECAM. Aside from other technical variations in these standards that don't concern us here they have different frame rates. PAL is 25 frames per second, NTSC is 30 fps and SECAM is 25 fps.

To confuse things even more, the frame rates for these video standards are further split into fields, with each field containing half a frame. In fact, the frame is divided into alternating lines, so that one is set odd and the next even (1, 3, 5 , 7... and 2, 4, 6, 8, etc.). The important aspect of this splitting is that the fields represent two different slices of time, so video can really be thought of as 50 or 60 fields per second, rather than merely 25 or 30 fps. The result is that time is sampled more finely by video and therefore motion is captured with greater resolution.

In film, the lower frame rate, combined with the technicalities of the way that an image is captured to film, results in something known as motion blur, a beneficial artefact that actually helps to smooth rapid motion by providing the impression of finer time sampling. Motion blur in film occurs when a fast-moving object changes its position while a single frame is being exposed. It's exactly the same as what happens when you move your head or arms during a long-exposure photograph.

129

3

ANIMATION 2

The human eye experiences a similar motion-blur effect, which is part of the reason that film motion blur looks so natural. Hold your hand up about 1½ ft (0.5m) from your face with only your index finger extended. Now shake your hand rapidly from side to side (in the same plane as your palm) keeping your finger rigid. You should see motion blur as your finger moves quickly and, if you are observant, two stationary fingers at the points where your hand changes direction! Try it in front of a TV set or monitor. You should see a collection of well-defined fingers silhouetted against the screen but no blur – the flickering of the CRT display creates a simulated 'sampling' of the motion.

As a 3D animator, it is necessary to know on which standard the animation is going to be played so that the animation software can be set up for 24, 25 or 30 fps beforehand. You also need to know whether you will output the rendered images as frames or fields. Some 3D artists deliberately render at the film frame rate, then stretch the footage temporally in a compositing program to get more of a 'film look'. This is because there's more to the look of film than merely the frame rate, including grain or noise, contrast and colour balance.

If you render a 3D animation at 24 fps as if it were film footage, then don't expect to see any motion blur. The perfection of the virtual camera in computer animation software is such that this real-world aberration is eliminated. Motion blur has to be put back into a 3D scene, often with great effort (on the part of the computer's CPU). Motion blur needs to be calculated and

1

With motion blur enabled, a moving object is rendered as a blur in the direction of motion. Vector motion blur does have limitations – notice that the teapot's shadow is not blurred.

2
Without motion blur in each frame, the object is rendered as normal even if it is moving fast. This can result in a jerky, stuttery-looking motion when the animation is played back.

3

added back into the final render as an additional process, which means that rendering realistic animations requires more computing power than a still image. It was only thanks to motion-blur simulation that the 3D dinosaurs in *Jurassic Park* made it to celluloid. Any 3D animation without motion blur will not blend well with traditionally shot footage, unless there is very little movement.

So if you are animating for broadcast or film, motion blur is going to be an important consideration. In 3D there are three types of motion blur – 2D, 3D and multi-frame. 3D motion blur uses sophisticated techniques to calculate highly accurate motion blur in three dimensions, but this is very time-consuming. An alternative is 2D motion blur, which uses a very simple technique for calculating motion-blur effects. For every element in the scene the motion vector is calculated with respect to the viewing plane. This means that the movement of every element across the screen is analysed and a motion-vector amplitude is calculated. Because only 2D vectors are calculated, the process is much quicker, though not quite so accurate as the 3D technique. Nevertheless the results of motion-vector motion blur are nine times out of ten indistinguishable from real footage to the average viewer.

Often with video footage you may not need software to calculate motion blur as the greater time sampling of video renders it unnecessary. Even with video there are times where a fast-moving object will require motion blur or you may suffer staccato, strobing animations.

3
With multi-frame motion blur, subframes are rendered of the scene or object and then blended together to give the final frame. This can be more accurate when lots of subframes are rendered but is very expensive computationally. This is because for each frame five or more frames are actually rendered. This image uses five-frame multi-frame motion blur and you can clearly see each subframe in the blur, though the shadow is now blurred too. The image took five times longer to render than the previous image.

KEYFRAME ANIMATION

In 3D, animation is achieved using a process called keyframing. This is a technique that derives its name from traditional 2D cel animation, where a key artist would block out the main poses of an animated character, letting assistant animators fill the frames in between. The keyframes were therefore the frames that were drawn by the key animator. In 3D animation you are the key animator and the computer is your assistant, ready to fill in the frames between the keyframes you set.

In the case of a simple animation, such as a ball rolling across the floor, you begin by setting a keyframe that records the starting position of the ball at frame 1. Then you move to the final frame of the animation, say frame 50, and move the ball 100 units in x and record another keyframe. The software interpolates between these keys to produce values for the ball's position at each frame between 1 and 50. The result is that the ball moves across the screen when you play the animation. A quick bit of simple maths will also tell you what values you use for the final rotation of the ball, given the 100 units it has travelled. The ball will then roll as it moves (without appearing to slide) across the screen.

The interpolation of keyframes, often known as 'tweening', is very important. A linear interpolation produces an

2
An ease-in, ease-out function curve looks like a gentle slanting S-shape.

1
The function curve shows how animation data changes over time. The vertical scale is the animation data value, and the horizontal scale is time.

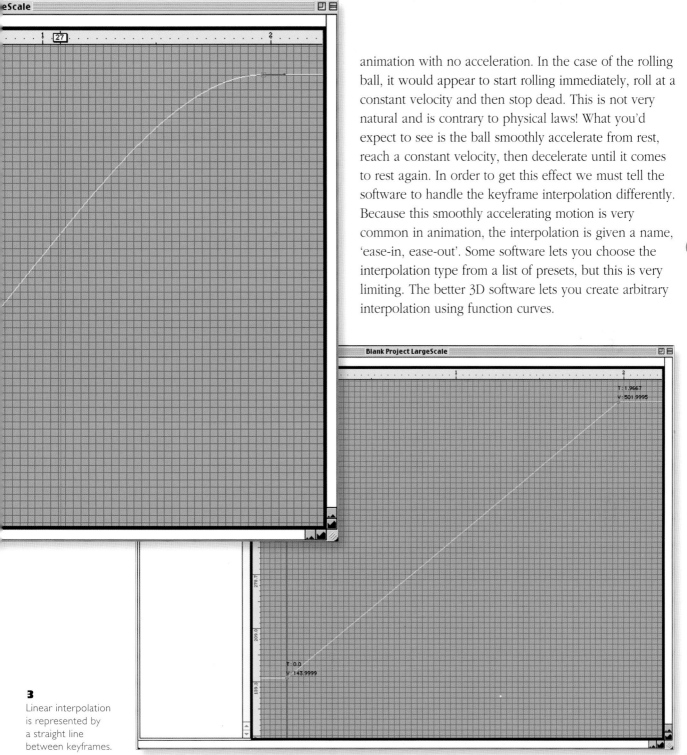

animation with no acceleration. In the case of the rolling ball, it would appear to start rolling immediately, roll at a constant velocity and then stop dead. This is not very natural and is contrary to physical laws! What you'd expect to see is the ball smoothly accelerate from rest, reach a constant velocity, then decelerate until it comes to rest again. In order to get this effect we must tell the software to handle the keyframe interpolation differently. Because this smoothly accelerating motion is very common in animation, the interpolation is given a name, 'ease-in, ease-out'. Some software lets you choose the interpolation type from a list of presets, but this is very limiting. The better 3D software lets you create arbitrary interpolation using function curves.

133

3
Linear interpolation is represented by a straight line between keyframes.

Function curves are graphical representations that demonstrate the way the animation data is changing over time, and they are drawn using a simple curve on a graph. An ease-in, ease-out curve would look like a slanting S-shape, while linear interpolation would be seen as a straight line.

A good function curve editor will let you modify the shape of the curve using tangent handles like a Bézier curve in a drawing program. This gives you excellent control over the curve shape without having to add extra keyframes. Another way to control the curves is to use TCB controls (Tension, Continuity and Bias), which are three values that a keyframe can have that modifies the shape of the incoming and outgoing curve. Other interpolation methods include Cubic, which is not so controllable but provides a useful smooth interpolation for some situations.

The best 3D computer software will allow you to mix these interpolation methods on the same function curve, which will give you the best control over timing that you could expect.

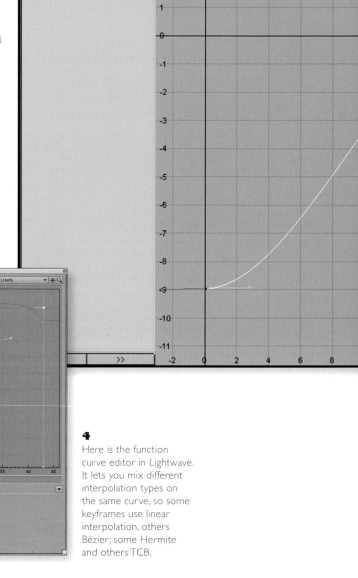

4
Here is the function curve editor in Lightwave. It lets you mix different interpolation types on the same curve, so some keyframes use linear interpolation, others Bézier; some Hermite and others TCB.

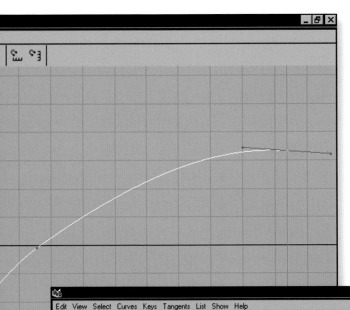

5

Breakdowns are special keys that keep their relative distance between their neighbouring keys. Here in Maya the breakdown lies between two Bézier keys.

6

By moving just the last keyframe backwards a few frames the breakdown moves too, maintaining its relationship between the two keys. This is very useful because you can use it to scale a segment of an animation without having to use a special tool or move each keyframe manually.

ANIMATING JOINTED HIERARCHIES

Though even intermediate character animation is beyond the scope of this book (we recommend the highly regarded *Character Animation* by George Maestri if you want to explore the nuances of animating 3D characters), we'll discuss some basic techniques and demonstrate some of the common methods used to animate digital characters.

A simple 3D character might be composed of a series of hierarchically linked objects, such as a head, torso, shoulder, forearm, hand and fingers, each of which is a separate object with its own carefully placed pivot point (Local axis).

When animating a character by rotating each object in turn in a hierarchy, you are carrying out what is known as Forward Kinematics (FK). When you move your arm in order to pick up something, you don't think about first moving your shoulder joint, then your forearm and then your hand; you just reach with your hand. In the computer this type of motion can also be achieved by using Inverse Kinematics (IK). With an IK hierarchy you grab the end object to rotate all the objects further up the hierarchy in one go.

Many 3D animators prefer to use FK for the arms of a character, but IK for the legs. They use FK for the arms because the legs usually have to stay planted to the floor. IK can be used for the arms when the character is holding onto something, for example if it is climbing a ladder. A 3D system that lets you use both FK and IK at the same time is advantageous, but in many 3D programs IK and FK are mutually exclusive.

136

2
If you try to rotate the pieces of the arm to animate it, the arm will come apart.

1
In a hierarchical arrangement of objects that are part of a 3D character, each object's Local axes needs to be properly positioned. Here is an arm in which each object's axes remain in their default positions.

3
By moving each object's axes near to the object that is its parent, rotating the objects creates the correct result.

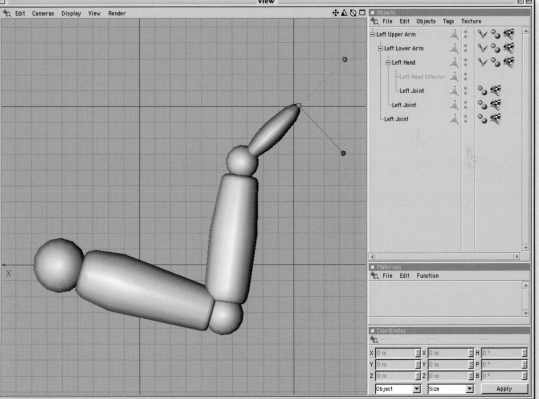

4
This arm has been set up to use IK and also feature a few extra objects in the hierarchy, though there are still three joints. With IK you usually need to specify where the start and end points of the IK chain are. The start is the shoulder, but the end in this case is a Null object, which has made a child of the hand. All you need to do to bend the arm is to move the Null.

ANIMATING SINGLE-SKIN CHARACTERS 1

So far we've seen examples for a character composed of separate objects linked into a hierarchy. Such a model is useful but not very realistic. To create a believable monster, human, dog, etc., you'll probably create the model using a single mesh of polygons or stitched NURBS surfaces. Since the model is a single object without a hierarchy, you need to create a skeleton so that the joints can be added back into the model.

There are two types of skeleton, one constructed of joints and one of bones. Joints and bones sound similar, but they work slightly differently and some programs favour one over the other. Their main purpose is to define a structure within the model that can be bent and moved like a hierarchical model. The resulting single-skin model is then linked to the skeleton in such a way that it deforms when the skeleton limbs are rotated.

It's the way the linking is done that makes joints and bones different. With a bone all the points on a linked skin model within a certain radius are affected by it. If you move the bone, then the points move with it. When two bones are linked to a skin model they are in competition for control over the points, so the points closest to each bone are 'captured' by it and move with

that bone. Near to where two bones are connected (a limb joint) the points make a smooth transition from being controlled by one bone to the other, and a few points are controlled by both at once. The result is that rotating one bone causes the skin to deform with the rotating bone in a natural way.

In a complex bone hierarchy all of the bones are in competition for all of the points in a mesh. Usually this results in the correct points being affected, but it can

138

2

1

1
Here is a simple flat plane with one bone linked to it. The bone is displayed as a toothpick-like object in the 3D view.

2
When the bone is rotated the entire plane moves with it because the points are fully influenced by the single bone.

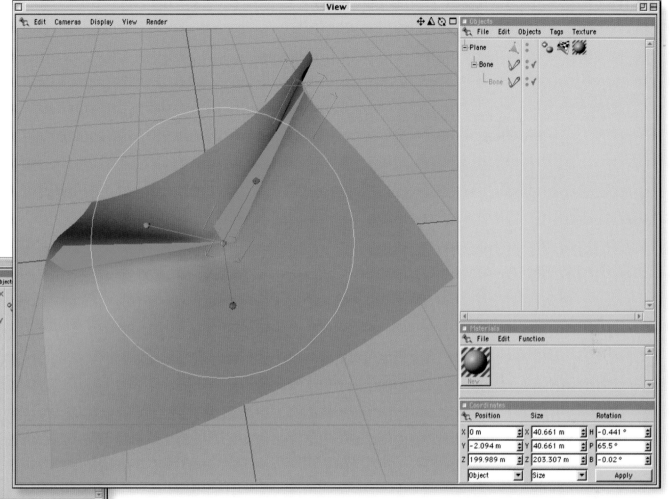

139

cause problems such as arm bones affecting the chest, etc. Animators will usually add special anchor bones to the model to hold in place parts of the model that they don't want to deform, such as the head and chest or perhaps equipment that the character is wearing.

In order to minimize this extra set-up you often see character models that are constructed in an 'X' stance, with their arms outstretched and level with their shoulders, and with their legs and fingers apart. This helps to keep extremities separated from other parts of the body so that, when boned, the deforming effects of the bones are restricted to those parts of the body they are meant to affect.

3
When two bones are linked in a hierarchy to the plane, something quite different occurs. Rotating one of the bones deforms the plane, since some of the points are captured by one bone while the rest are captured by the other bones.

ANIMATING SINGLE-SKIN CHARACTERS 2

2

With skeletal joints, points are assigned to bones directly, no matter what distance they are from the joint. In other words, a single mesh with one joint would not necessarily have all its points captured. In a hierarchical set-up the joints have points allocated to them, then near to the area that will be deformed the points must be 'weighted' between each pair of joints. Some programs link the joints in a skeleton without weighting the points between each pair of joints and this results in a rigid binding; points belong to either one joint or another. When you rotate a joint in this type of set-up the mesh will not deform smoothly so a complex series of special devices called lattices is used to create smooth deformations.

persp

1
A single-skin character is, as its name implies, constructed from a single mesh of polygons or a single parametric surface. This polygon velociraptor has had a jointed skeleton built inside it, to which it will later be bound. The process of binding, or skinning as it is sometimes known, maps the mesh vertices to particular joints in the skeleton based on a distance.

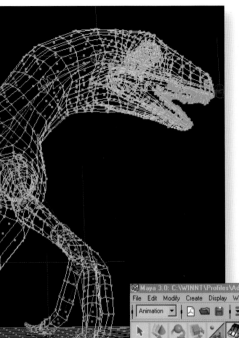

2

With joints, points are linked to individual joints by the process of binding. In this example colours are used to show which points are bound to which joints.

3

Weighted, or smooth binding, results in smooth joint deformations, because the points are mapped to joint pairs using a weighting value. Unlike bones, joints only affect specific points, not the whole model. In Maya the weights can be visualized as greyscale values displayed on the mesh in OpenGL. A brush can then be used to paint or smooth the weighting.

141

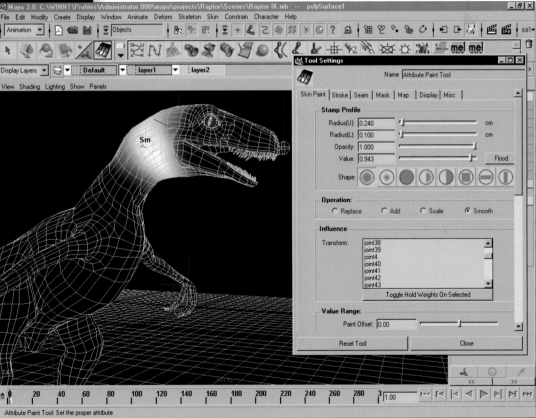

3

ANIMATION GUIDELINES

One of the great advantages of 3D computer graphics is the total freedom you can have with animation. Almost everything can be animated, but just because you can animate something doesn't always mean that you should. A prime example of this is the camera. It's very easy to animate a 3D virtual camera. It has no weight, so there's no cameraman, tripods or dollies to lug around and set up. If you want to do a crane shot, you don't need to hire the equipment, there's no worry about the weather being unsuitable and you don't have someone to tell you 'You can't do that'. Because 3D cameras can move through objects, and move in ways that are impossible to re-create with traditional photography, it's very easy for an inexperienced animator to get carried away.

Wild camera moves are distracting, and sometimes even uncomfortable, to watch. A demo reel full of animations where half of the action is due to the camera moving all over the place doesn't look professional.

The best way to learn about camera techniques is to watch some films or TV programmes and make notes. Most of the time the camera is hardly moving, and variation is provided by editing between different shots rather than moving the camera itself.

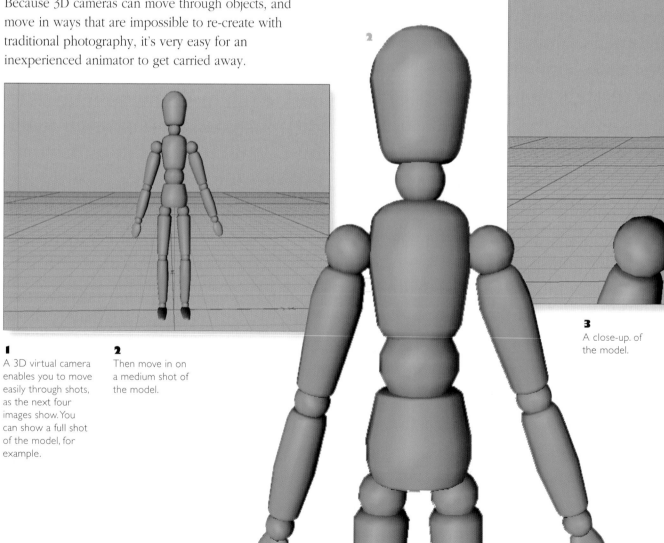

1
A 3D virtual camera enables you to move easily through shots, as the next four images show. You can show a full shot of the model, for example.

2
Then move in on a medium shot of the model.

3
A close-up. of the model.

If the camera does need to move, then gentle, considered movements are recommended. Generally camera moves should not draw attention to themselves – the exception being, of course, if you want to create a special effect. For example, a good technique is to shake two camera position channels using a succession of randomly generated keyframes to simulate the effect of a shockwave hitting the camera. Another similar technique is achieved to generate POV (point of view) shots. Some

randomization of the keyframe data can be used to create hand-held camera effects or to simulate a bumpy road surface if the POV is from a person riding in a car.

Toy Story is a good film to watch for tips on many aspects of 3D animation. The camera work is very controlled, but creative too. However it is also a good idea to get yourself a book on cinematic photography techniques for more detailed descriptions of techniques that can be incorporated into your 3D animations.

143

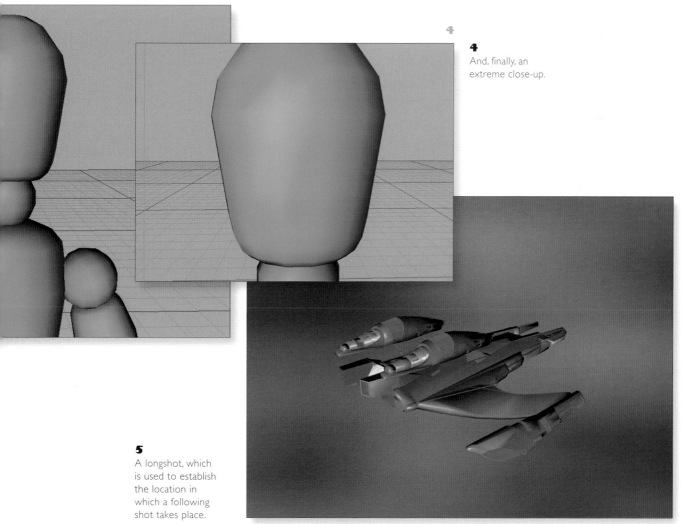

4

4
And, finally, an extreme close-up.

5
A longshot, which is used to establish the location in which a following shot takes place.

5

1
144

When cutting between two characters in conversation you must take care to observe the line of sight when placing the camera. The camera must always be on one side of the line of sight in such a situation. If the camera passes the line of sight, it will appear that one of the characters is facing the wrong way and you'll undoubtedly end up confusing the viewer.

1

2
The line of sight is an imaginary plane between the two characters.

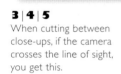

3 | 4 | 5
When cutting between close-ups, if the camera crosses the line of sight, you get this.

6 | 7 | 8
If the camera remains on the same side of the plane there is no confusion, and both characters appear to be talking to each other.

UV TEXTURE MAPPING 1

Projections are one way in which to apply textures to objects, but there is also another method of applying textures – UV texture mapping. Projection mapping is used because the 3D software doesn't have any understanding of the structure of the surface. In the case of NURBS models, however, the structure of the surface is well known. A NURBS surface is constructed of curves that run in two directions perpendicular to each other. Even if the NURBS surface happens to be wildly convoluted, this surface structure is always maintained. In the same way as the x and y coordinates of 3D space, locations on a NURBS surface can also be described in terms of coordinates. These coordinates are called 'U' and 'V' and represent the opposing directions that the curves follow.

1
A flat NURBS plane would have U along one direction and V along the other. The corner that has both u and v values of 0 is the origin of the surface, written 0,0. In the opposite corner the UV values are 1,1. A point anywhere on the surface can be located by finding its U and V coordinate values.

1

2
Here is a simple texture applied using UV mapping to a finger-like object.

3
Because the texture is effectively locked to the UV coordinates, you can deform the object and have the texture deform with it. In fact, as far as the texture is concerned, the UV coordinates of the surface are not deforming at all.

Basically with UV mapping, as it is called, everything boils down to a simple flat projection, no matter what the actual shape of the surface is. Every NURBS surface in UV coordinate space looks like a flat plane, and it is extremely easy to map a flat plane.

The other property of UV texture mapping is that it is possible to stick the texture to the surface. The texture is pinned down, as it were, at the NURBS CVs so that as the object is deformed, the texture is deformed along with it.

147

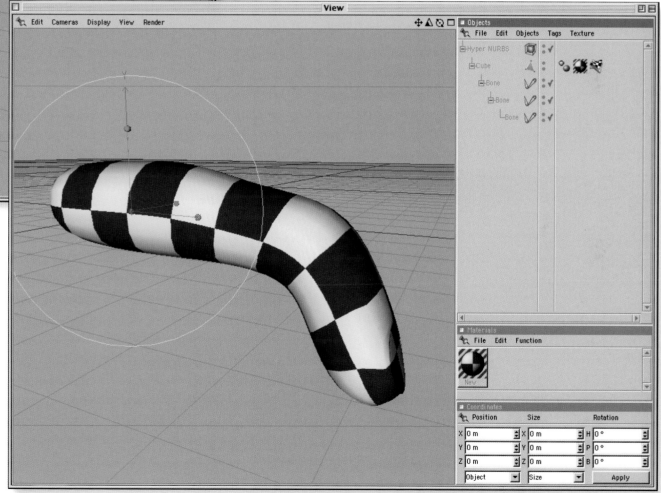

3

UV TEXTURE MAPPING 2

The unique feature of UV textures is that the UV points can be moved in relation to the texture image. This has the effect of letting us distort the texture image so that it more accurately fits the object on which it is being mapped.

In some systems this UV mapping process can be taken a step further by allowing the artist to paint the texture map directly on the object using the UV coordinates as a guide. This has obvious benefits since it takes the guesswork out of placing details in textures.

1

Here is an image of the area around an eye being mapped using default UV coordinates. As you can see, it doesn't quite fit.

148

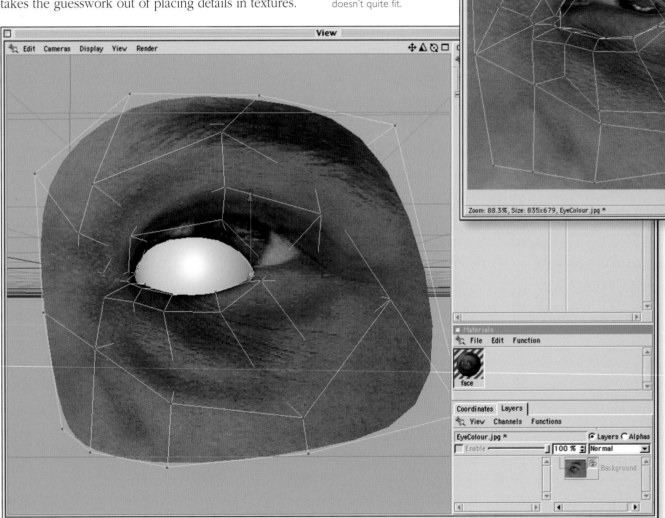

1

2

You can view the UV points of the object as a flat 2D plane and place the image underneath. This lets you see exactly how the UV points (or rather the surface points with known UV coordinates) lie in relation to the texture image.

3

By moving the UVs you can line them up with features in the face image, thus making the image stretch to fit the geometry in the 3D view. The result is a perfectly mapped object.

Zoom: 88.3%, Size: 835x679, EyeColour.jpg *

GENERATING UVS FOR POLYGON OBJECTS

NURBS surfaces are not the only geometry type that can utilize UV coordinates. As we have seen, there's no way for the software to work out the UV coordinates of an arbitrary polygon mesh since there may not be a well-defined U and V direction. However you can force the UVs onto a mesh that has already had a projection applied to it. Thus you effectively 'bake' the UVs into a polygon mesh based on an initial projection method, be it planar, cylindrical, spherical, etc.

150

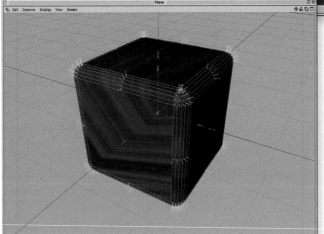

1
A polygon surface has no UV information by default, which is why you have to use projected textures.

2
Once the projection is applied you may have the option (depending on the software) to bake the texture coordinates into the polygon points based on the projection.

3
This lets you use the same UV editing tools on polygon objects as for NURBS, enabling you to adjust the texture to make it fit the object better.

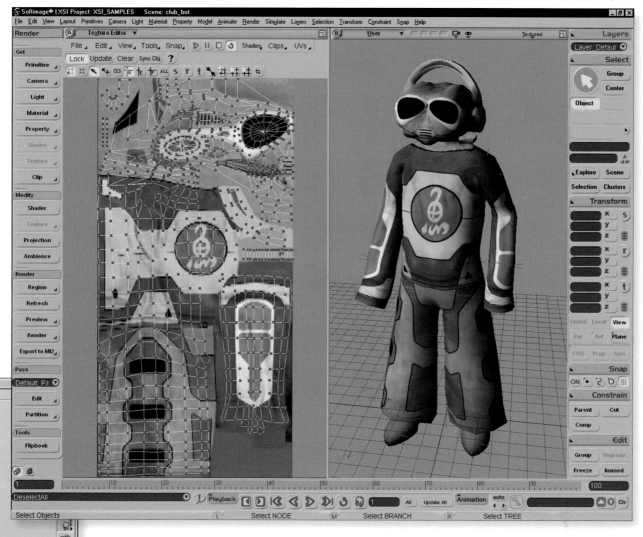

4

Here is one of the models that ships with Softimage XSI. The colour texture for the robot is a single image map, with each section positioned to make maximum use of space in the image file. Features that are duplicated, such as each side of the face, legs and arms are only painted once in the map. By overlapping UVs that share a common part of the image, the details can be duplicated in different parts of the model. This is a good way to save time. If you have repeating details, you can paint just one iteration of the detail and make it repeat by overlapping the UVs in the 3D program. Many programs let you cut and paste large sections of UVs to speed up the process.

You can think of the initial projection as a starting point. Once the texture coordinates have been baked into the polygon surface, it can be unwrapped (or rather the projection is unwrapped, taking the polygons with it) and viewed as a flat plane. You can then begin moving the UV points so that the texture is more accurately positioned on the mesh.

With UV textures you have the option to put all of your bitmap textures in a single image file for each channel. The position of any given surface texture detail in the image is not important, so the texture can be optimized without wasting much space.

3D ON THE WEB • 154

VRML • 156

VIEWPOINT • 158

CULT3D • 160

CRYONETWORKS • 162

HYPERCOSM • 164

SUN AND JAVA 3D • 166

OTHER OPTIONS: PRE-RENDERED 3D SCENES • 168

152

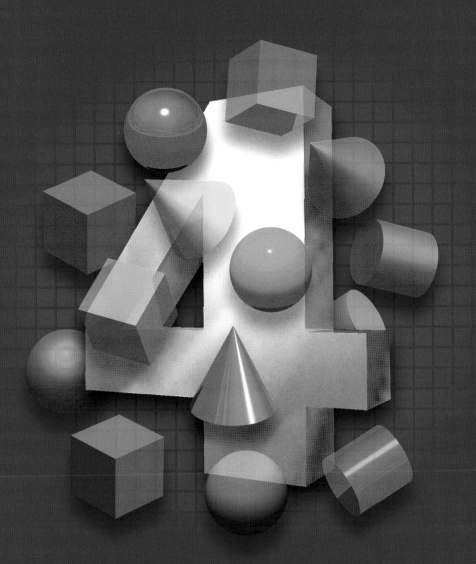

3D ON THE WEB

One of the emerging uses of 3D graphics is on the Web. It is inevitable, really, because 3D is the natural extension of the traditional 2D imagery that is so prevalent in today's Web content.

There are hurdles to overcome when it comes to delivering 3D content on the Web, though. The initial difficulty arises from the amount of data that goes into describing a 3D scene or object. When producing 3D work locally on your own computer, the size of the files you produce is not too much of a concern, especially with today's large-capacity hard drives, which are usually tens of gigabytes as a standard. If you had to transmit that data to someone else via the Internet using a 56k modem, however, the receiver would have a long wait.

What is needed is some way to reduce the information that is transmitted without degrading the 3D information too much. It's the same compromise that is faced by 2D designers who are optimizing images for the Web.

There are many companies working on their own custom schemes for producing this sort of 3D data compression, each hoping to become the standard. Flash is one example. It is more or less the standard for delivering rich 2D animated content with minimal data rates, so a 3D Web standard version would provide a universal solution that every browser and every 3D program would support.

The delivery of 3D content on the Internet falls into two broad categories, streaming and non-streaming solutions. Non-streaming solutions have been around for a while and rely on simple compression of the 3D data and texture to minimize transfer times. Technologies such as VRML and QuickDraw 3D are non-streaming, which means that the entire 3D data must be downloaded before it can be displayed. With 3D content of any detail this means a long wait before the viewer sees the 3D object or scene in their Web browser – long enough for them to get impatient and go elsewhere.

■
Apple's QuickDraw 3D technology was pushed as a standard for interactive 3D graphics such as QuickTime and has become a standard for movie playback. Apple has since dropped support of QuickDraw in favour of OpenGL.

Streaming 3D incrementally delivers the data, which is reconstructed as and when the information is received. The model may be displayed almost immediately in a very rough, low-resolution form but then, as more data is downloaded, the model becomes more detailed. This is obviously a superior, more elegant solution than the non-streaming alternatives, and shows why most of the research effort in this field is in streaming 3D content. Streaming 3D lets you see the 3D model in stages and allows you to interact with it while it is downloading.

In both cases the 3D data is sent raw and reconstructed at the viewer's browser, usually with the help of a plug-in. The 3D object or scene is then rendered directly in the Web browser on the fly, so that the viewer can interact with the 3D object, rotating or zooming in on it. In this way 3D content can be seamlessly integrated into Web pages without the need for a stand-alone application for viewing.

At the moment there are numerous offerings and this chapter gives you a taste of them.

2
QuickDraw 3D can be used to produce interactive 3D such as this rollercoaster ride game.

VRML

Virtual Reality Markup Language, or VRML, is a non-streaming format touted by the non-profit-making organization the Web|3D Consortium as the Internet standard for delivering interactive 3D content over the Web. It's now, in reality, a dinosaur that never actually delivered a truly interactive, rich 3D experience, due to the clumsiness of the delivery method.

The Web|3D Consortium is currently putting forward a new standard X3D to replace VRML, but it is likely to be usurped by companies researching streaming 3D content delivery. In the same way Macromedia's Flash became the *de facto* standard thanks to massive publicity by the company, despite other 'official' standards already put in place.

1

1
VRML can be output by most 3D programs, but since it requires a full download of the 3D data before displaying in the destination browser, it's a clumsy and slow way to create 3D worlds online.

2
VRML has been a successful system for Web 3D and the file format is supported by most 3D programs. However don't expect anything as exciting or impressive as this image in your browser.

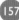

157

3
Though people are finding new and (probably) exciting uses for 3D graphics on the Web, it's obvious application is for creating 3D environments. VRML has been used for games and chat room 'worlds' such as this.

VIEWPOINT

Viewpoint was bought by MetaCreations, the company that was originally responsible for creating Photoshop plug-ins such as KPT, and 3D programs like Bryce and Poser. It subsequently divested itself of its graphics division to concentrate on interactive 3D for marketing, based around its Metastream technology. After buying Viewpoint and absorbing its vast libraries of 3D models, it dropped the MetaCreations moniker in favour of Viewpoint.

Viewpoint also licenses its streaming technology to other companies. Adobe, for example, has recently licensed it to create its own interactive and streaming 3D authoring environment, called Atmospheres. Based on the Viewpoint technology, it allows designers to create engaging 3D websites with the typical Adobe ease of use.

There are a number of programs that can export to the Viewpoint streaming format (previously called Metastream) including Poser 4 with Plus Pack, Cinema 4D XL and 3D Studio Max.

158

1 | 2 | 3

The Viewpoint 3D format, previously called Metastream, delivers 3D models using streaming technology via the Viewpoint Media Player, the free browser plug-in required to view and interact with the 3D objects. At the time of writing, it seems to be the best option in terms of speed and quality. Viewpoint also supports animation, so not only can the 3D content be manipulated by the user, but with a simple click it is capable of performing some action too.

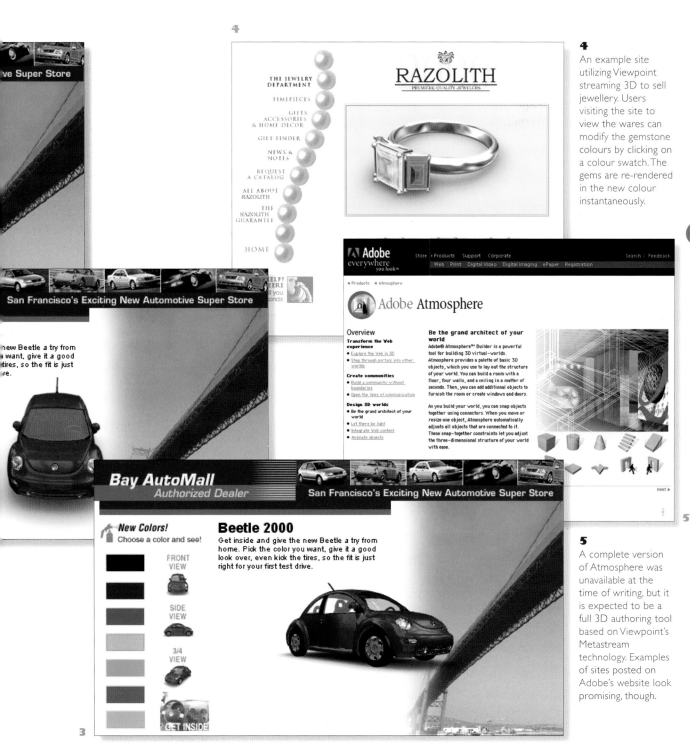

4

4
An example site utilizing Viewpoint streaming 3D to sell jewellery. Users visiting the site to view the wares can modify the gemstone colours by clicking on a colour swatch. The gems are re-rendered in the new colour instantaneously.

5
A complete version of Atmosphere was unavailable at the time of writing, but it is expected to be a full 3D authoring tool based on Viewpoint's Metastream technology. Examples of sites posted on Adobe's website look promising, though.

5

3

CULT3D

Cycore Computers offers up Cult3D, another potential streaming standard that is vying for dominance. Cult3D is a program that has similar streaming capabilities to Metastream (*see pages 158–59*), although it does not seem to have secured the backing that Viewpoint has managed to acquire.

Graphics home

Pick of the day
Advisory
History
Services
Team
Technical

You will need the CULT3D plugin (1.2mb) to view the MIR graphics

GetCYCORE Cult3D

Topics
MIR Space Station 3D
MIR Interactive 3D
Feedback

DRAG ON OBJECTS WITH YOUR MOUSE

Animated graphic sequence courtesy Cult3d.com

Legal | Copyright | Privacy |

REUTERS

1
Like Viewpoint, Cult3D requires a free viewer plug-in for your Web browser.

2
You can interact with the streaming 3D model in real-time, rotating or zooming in on it.

2 Legal | Copyright | Privacy |

in (1.2mb) to view the MIR graphics

'S WITH YOUR MOUSE

uence courtesy Cult3d.com

3

Cult3D even produce a product called 3D Me, which can be used to create personal Avatars (3D representations of real people) using a simple photo of the front and side of their head. This can be animated and placed on a Web page.

3

CRYONETWORKS

Cryonetworks is a French company that has produced an entire language for delivering 3D multi-media sites capable of replacing HTML-based Web browsers and streaming media viewers. The language is SCOL and it provides a complete multi-media authoring framework that can incorporate 3D graphics, sound, QuickTime movies, chat rooms, HTML and Java, and it can also be used to create multi-user virtual environments.

Though the meat and potatoes of this interactive 3D experience is displayed using special software, the SCOL Voy@ger, access to the sites can be broadcast using traditional browsers, which then open the SCOL Voy@ger application when you enter the site proper.

The downside to SCOL is that it is totally proprietary, needing unique software and hosting requirements, so it is not widely accepted. However it does show that there are alternatives to the Web browser plug-in approach that has been taken by the majority of developers.

1
This is the Cryopolis site (**www.cryopolis.com**), which has been accessed using the SCOL Voy@ger from Cryonetworks. It's a multi-user 3D environment, complete with sound and chat. You can navigate the site by wandering around the 3D scenery, enter buildings and meet other users.

2 | 3
Another SCOL site is Fog (**www.fogmysteries.com**), an online adventure/whodunit game in which you are a detective trying to solve a mystery. You can choose a character and enter the site as a fully animated 3D character. The graphics are comparable to a simple console game, but it is made more interesting because of the interactivity and multi-player nature.

3

HYPERCOSM

Hypercosm gears its 3D system for the 'eCRM' market or online customer relations. It's also a useful system for designing online tutorials, instructions for equipment and manuals for assembly and installation. Other uses include online virtual galleries and 3D representations of complex analytical data.

The interactive demo for a Hewlett Packard printer uses the Hypercosm Netscape plug-in to display the 3D object in real-time, and provide animated instructions.

3D Web content is a useful way to provide instant training and instructional content and has many different uses. An animated set of instructions in 3D for assembling a piece of equipment (or furniture), as long as they have been well designed, could be more useful than the exploded diagrams we have been used to.

164

2

If tray is not already set to desired paper size, snap guides into place to match width of paper.

HP Printer

, products, logos, or brands are property of the he

copyright © 2000 Hypercosm, Inc. | Showcas

1

Pull the tray completely out of the printer.

Step 1
Step 2
Step 3
Step 4
Step 5

Main Menu
Reset Eye

HP Printer

HP, its marks, products, logos, or brands are property of the hewlett-packard company.

copyright © 2000 Hypercosm, Inc. | Showcase | Back

If tray is not already set, squeeze the blue tabs and slide the back section of tray to desired paper size.

Step 1
Step 2
Step 3
Step 4
Step 5

Main Menu

Reset Eye

HP Printer

P, its marks, products, logos, or brands are property of the hewlett-packard company.

copyright © 2000 Hypercosm, Inc. | Showcase | Back

165

1 | 2 | 3

This is an interactive demo for a Hewlett Packard printer. It uses the Hypercosm Netscape plug-in to display the 3D object in real-time, and also provides animated instructions.

SUN AND JAVA 3D

Sun is the company that developed the platform-independent Java programming language. Java is a platform-independent environment in which programs written in the Java language can run irrespective of the machine they are running on. Java implements a 'virtual machine' that is like a software ideal of a computer, isolating the program and any calls it makes to hardware from the actual machine the environment is running on.

Sun has now also introduced an extension to the API, called Java 3D, which provides interactive 3D for Java. It is currently only available for Windows and Unix systems, but a Mac version is expected soon. The good thing about the Java 3D program is that you can download and display interactive 3D content from any Java-enabled browser without the need to download a plug-in first.

This 3D option is intriguing and elegant because it is totally platform and browser independent. That means that there's no need to download and install a new plug-in each time the format is upgraded – and how many times have you had to do that with Flash?

So there are a number of contenders all with excellent offerings, and it's only a matter of time until we find out which will become the standard. However, it's likely to be the solution that offers the richest experience and the speediest downloads that wins through, though a fair amount of publicity will no doubt be a deciding factor too.

166

2

Intel® Pentium®II Xe

• **Cartridge**

► **Substrate**
- Level 2 cache
- SMBus
- Thermal sensor
- Scratch EEPROM
- PIROM

• **CPU core**

Sound On
Narration On

The CPU co
interface are
processor's .

Intel® Pentium®II Xeon™ Processor

► **Cartridge**
- Connector
- Thermal plate
- Heat sink
• **Substrate**

• **CPU core**

Sound On
Narration On

Developed by Intel, the Single Edge Contact (S.E.C
high-volume availability, improved handling protect
common form factor for future Pentium(R) II Xeon(TM) processors.

1

3

Intel® Pentium®II Xeon™ Processor | tour

- **Cartridge**

- **Substrate**

▶ **CPU core**

 Level 1 cache
 Thermal diode
 450/400 MHz cor
 speeds

 Sound On
 Narration On

The Pentium(R) II Xeon(TM) processor's 450 MHz or 400 MHz core speeds work in tandem with the L2 cache. This makes an unprecedented amount of data available for processing.

1 | 2 | 3
This site uses Java 3D to create the interactive tour of the Intel Pentium processor. Though, like the processor, Java 3D is slightly slower than the other streaming 3D alternatives, there is no plug-in to install so the site can be accessed immediately. This site uses the SpaceCrafter pure Java Rendering engine by InWorld VR Inc.

167

Processo

ache and the new System Management bus
e mounted directly to the substrate inside the
cartridge.

OTHER OPTIONS: PRE-RENDERED 3D SCENES

There are alternatives to sending the actual 3D data to a viewer's browser. With Flash you can pre-render the images and convert them into Flash vector data, which is much more efficient and faster than sending compressed bitmaps. Some 3D programs let you render directly to Flash format, which is a big plus and saves a conversion step.

The other way is with good old GIF animation. It's clunky and not terribly efficient, but for many uses a GIF animation may suffice. However, there are limitations with the pre-rendered option. There is little or no interactivity, or, if there is, it has to be worked out in advance. With Flash there are no complex materials for objects, since it works best when areas of flat colour are used. A cartoon 3D look will usually be the result with material details such as reflection, transparency and bumps removed, and graduated shading will be reduced to three or fewer flat areas of colour. Nevertheless, you

3

2

Hoover website

® Registered trade n

3
GIF animation is a cheap and cheerful way to get your 3D animation on the Web. It's not interactive in the same way as true Web 3D, and the images have to be sent to the browser, which can take some time.

2
Flash is based on vectors rather than bitmaps so only the information required to create the images is set rather than the images themselves.

1
Cartoon-look images are suited to Flash-based animation because they are made of areas of flat colour. You could model characters like this in 3D for Flash output.

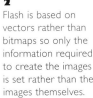

still have the power of perspective, movement, colour and scale to play with, which can be put to use with great effect by using Flash and a 3D program.

The precise shape and scope of 3D graphics on the Internet is uncertain, but it is inevitable that 3D graphics will become a major player in Web marketing, gaming and communication. Precisely what form the next generation of 3D Web graphics will take and how it will be delivered remains a subject of speculation, but the fervour with which companies are currently developing 3D Web technology indicates that the picture will clarify sooner rather than later.

ARCHITECTURE • 172

ARTISTIC/ILLUSTRATION • 174

PHOTOREALISM • 176

REAL-TIME 3D • 178

PRODUCT VISUALIZATION • 180

ARCHITECTURE

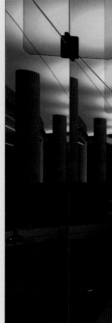

3D graphics are ideal for visualizing architectural designs. Instead of building scale models out of foamboard and balsa wood, a 3D model can be generated from architectural plans using a computer.

With realistic lighting a 3D render can help show how light in a building will look. Simulations can be carried out to show how lighting will change throughout the year and, by using radiosity techniques, accurate renderings of buildings and lighting can be achieved.

2
3D rendering aids the process of visualizing interior spaces. Radiosity and raytracing can help show how a space will look when actually built (image © Hammel, Green and Abrahamson, Inc.).

3
3D rendering can help architects to visualize how the chosen building materials will look in the final building (image © Michael D. Abbott/ Vantage Graphics & Design Ltd).

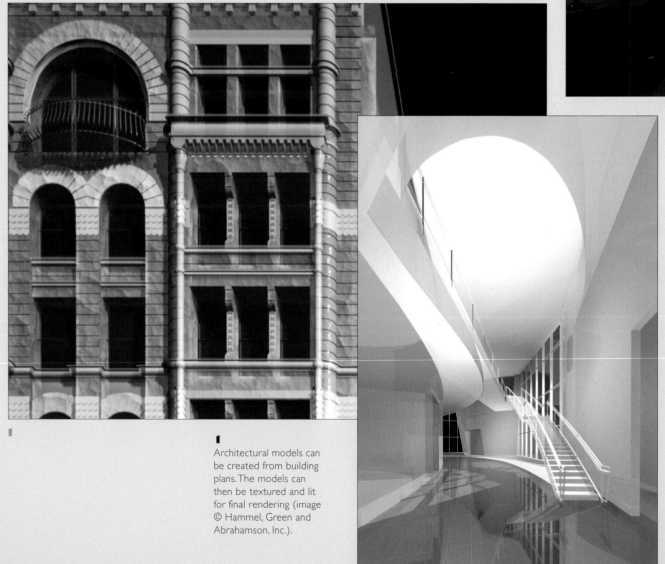

1
Architectural models can be created from building plans. The models can then be textured and lit for final rendering (image © Hammel, Green and Abrahamson, Inc.).

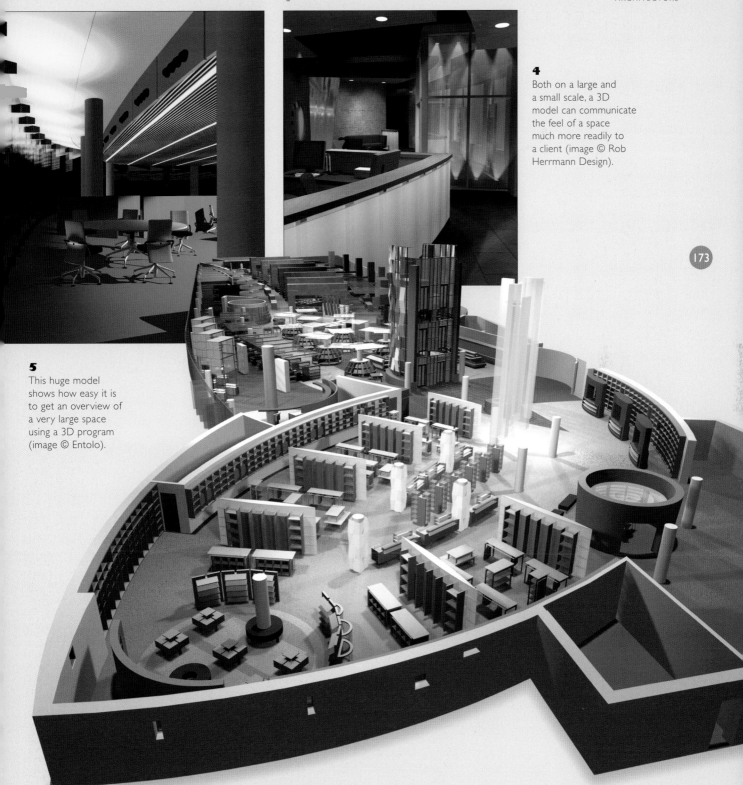

4
Both on a large and
a small scale, a 3D
model can communicate
the feel of a space
much more readily to
a client (image © Rob
Herrmann Design).

173

5
This huge model
shows how easy it is
to get an overview of
a very large space
using a 3D program
(image © Entolo).

ARTISTIC/ILLUSTRATION

3D graphics are used by digital artists to create illustrations for print and the Web. With a 3D program there are no limits to what can be achieved, and often artists will choose not to go for the photoreal look when creating 3D illustrations. Thankfully, 3D programs allow you to create hyper-real-looking images just as well as photoreal ones.

3
This image rendered in ElectricImage is a good example of extreme hyper-real surfaces. The metal in the image looks particularly lush and rich (image © Paul Sherstobitoff).

3

1

1
This illustration by the author was created for *MacUser* magazine. The petals on the flower were textured in order to enhance their edges and provide a stylized look to the image.

2
This simple and tranquil scene makes good use of scene fog effects (image © William Green).

2

4
An image created for *Computer Arts* magazine by the author. Rounded edges in the model help to define the shapes by catching specular highlights.

5
This image, another created for *Computer Arts* magazine by the author, uses luminance maps for most of the illumination. The only real lights are the four spotlights and an uplight.

4

5

PHOTOREALISM

One of the main uses for 3D graphics is creating images that attempt to look like the real thing. Every artist has his or her own trick for achieving a photorealisitc look, but lighting is the key ingredient. Though none of the images below uses radiosity, they all approach realism in varying degrees.

Most of the mid- to high-range packages can be used for photoreal rendering, though some are easier to use than others. Cheaper 3D programs are more limiting.

3
Simple everyday objects can be used for rendering studies. This image created for *Computer Arts* magazine by the author demonstrates that modelling detail can also play a big part.

176

1
Exterior scenes in bright sunlight tend to have hard shadows and lots of contrast. This temple image demonstrates this well (image © Eric Hanson).

2
Intricate texture details can work wonders. This incredible image has excellent texturing on the ants and the vegetation (image © Cristobal Vila, Eterea Animation Studios).

4
Despite not being rendered using radiosity, this image shows the effect of exterior lighting on an overcast day. The soft diffuse shadows and lighting are created using a Lightwave plug-in called, appropriately, Overcaster (image © AKMP-Program Oy 2001).

5
Creating realistic gold and metal can be a tricky business. If you want to render a reflective metallic object in isolation you'll need to add an environment map or there will be nothing to reflect (image © Cristobal Vila, Eterea Animation Studios).

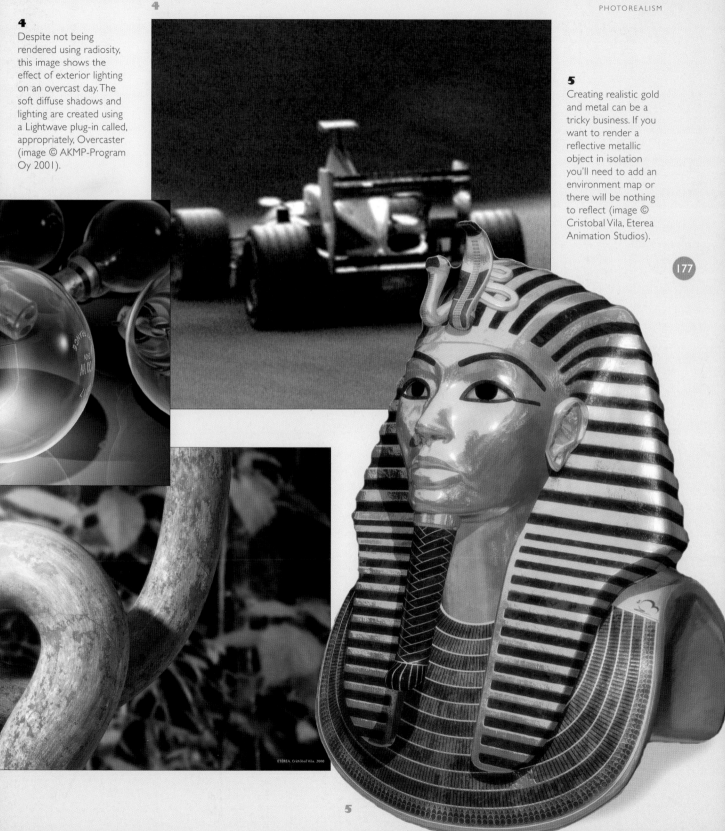

ETÉREA, Cristóbal Vila, 2000

4

5

177

REAL-TIME 3D

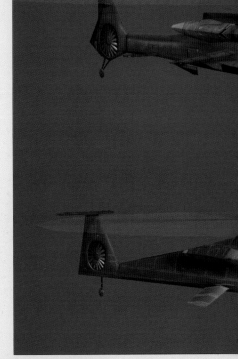

2

For real-time use you need to make special considerations for the modelling and texturing. For games and any interactive 3D use, models need to be 'light'. In other words, they must be made up of as few polygons as possible. The heavier the model, the longer it will take a games console or computer to display it and this will impact interactivity.

Game modelling requires a special skill, where economy is king. All the models on this page are created using only a handful of polygons; clever texturing then makes up for what is missing.

2

Clever texturing helps to make low-resolution models more believable. The spinning rotors on these helicopters are made to look like blurred rotorblades by using a texture map (image © Geoff Holman).

1

A typical game model, this tank is made using only a small number of polygons. The less work a console or computer does trying to draw the model, the faster the game will run (image © Geoff Holman).

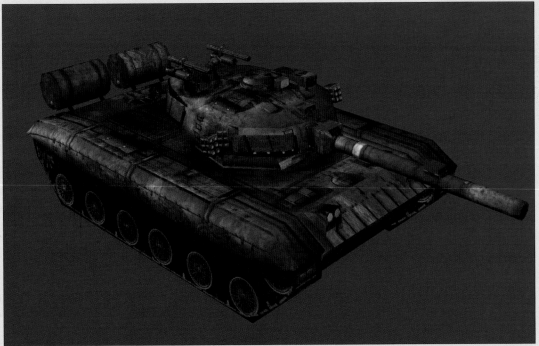

1

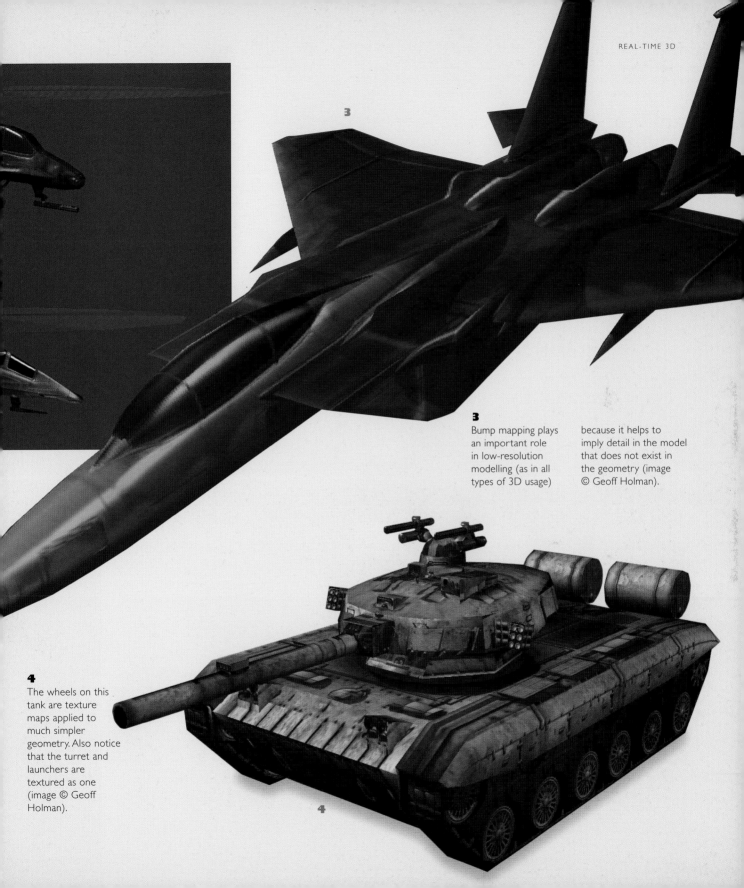

3

3
Bump mapping plays an important role in low-resolution modelling (as in all types of 3D usage) because it helps to imply detail in the model that does not exist in the geometry (image © Geoff Holman).

4
The wheels on this tank are texture maps applied to much simpler geometry. Also notice that the turret and launchers are textured as one (image © Geoff Holman).

4

PRODUCT VISUALIZATION

3D graphics also play an important role in product design. Prototypes and initial designs can be created and visualized entirely in the computer if necessary and, though not a substitute for holding a real model, a 3D render makes presenting designs to a client a lot easier.

The beauty of 3D models as opposed to real ones is that they can be built once, but textured many times. Different material for a product can be visually tried out in minutes and it's easy to change a part of a model without rebuilding the whole thing from scratch.

3

2

1
This minimal design shows how a 3D render can accurately represent the visual and textural qualities of a yet-to-be-built object (image © Dimitris Ladopoulos).

2
Prototypes can be visualized using a variety of materials very simply (image © Dimitris Ladopoulos).

3
3D programs don't limit your arrangement of a product shot like gravity can. Creating images of products that do exist is another use for 3D rendering. It's often much cheaper to pay a single artist to render a product than to hire a photographer and studio (image © Dimitris Ladopoulos).

4
Rendering an object from different angles and with dramatic lighting helps to gauge the form of an object from a single image. The stylish lines of this stool look very pleasing in this simple but effective render (image © Michael D. Abbott / Vantage Graphics & Design Ltd.).

4

GLOSSARY • 184

INDEX • 188

GLOSSARY

3D Three dimensional, that is, an effect to give the illusion of depth on a flat page or monitor.

Aliasing The jagged edge of bitmapped images or fonts occurring either when aliasing resolution is insufficient or when the images have been enlarged. This is caused by the pixels – which are square with straight sides – making up the image becoming visible. Sometimes called 'jaggies', 'staircasing' or 'stairstepping'.

Alpha channel A place where information regarding the transparency of a pixel is kept. In image files this is a separate channel – additional to the three RGB or four CMYK channels – where 'masks' are stored, simulating the physical material used in platemaking to shield parts of the plate from light.

Ambient A term used in 3D modelling software to describe a light source with no focus or direction, such as that which results from bouncing off all objects in a scene.

Animation (1) The process of creating a moving image by rapidly moving from one still image to the next. Traditionally, this was achieved through a laborious process of drawing or painting each 'frame' (a single step in the animation) manually on to cellulose acetate sheets ('cels', or 'cells'). However, animations are now more commonly created with specialist software that renders sequences in a variety of formats, typically QuickTime, AVI, Flash and animated GIFs.

Animation (2) A 'lossless' compression setting ('codec') used by QuickTime, which will work with all bit depths. Since it is very sensitive to picture changes, the Animation codec works best for creating sequences in images that were rendered digitally.

Anti-aliasing A technique of optically eliminating the jagged effect of bitmapped images or text reproduced on low-resolution devices such as monitors. This is achieved by blending the colour at the edges of the object with its background by averaging the density of the range of pixels involved. Anti-aliasing is also sometimes employed to filter texture maps, such as those used in 3D applications, to prevent moiré patterns.

API (Application Programming Interface) Special computer code supplied by a developer that can be used by other developers to implement a process in their software, such as OpenGL.

Area light A special light type that emits from a 2D area rather than a point.

Axis An imaginary line that defines the centre of the 3D universe. In turn, the x, y and z axes (width, height and depth, respectively) define each of the three dimensions of an object. The axis along which an object rotates is the axis of rotation.

B-Spline A type of curve.

Bank Another term for roll, or rotate about an object's local z axis. Also applies when an object rotates along its motion vector.

Bevel To round or chamfer an edge. Can also mean to extrude a polygon along its Normal producing bevels around its perimeter.

Bézier spline A Bézier curve in drawing applications is a curved line between two 'control' points. Each point is a tiny database, or 'vector', which stores information about the line, such as its thickness, colour, length and direction. Complex shapes can be applied to the curve by manipulating 'handles', which are dragged out from the control points.

Bitmap Strictly speaking, any text character or image composed of dots. A bitmap is a 'map' of 'bits' which describes the complete collection of the bits that represent the location and binary state (on or off) of a corresponding set of items, such as pixels, which are required to form an image, as on a display monitor.

Blend The merging of two or more colours, forming a gradual transition from one to the other. Most graphics applications offer the facility for creating blends from any mix and any percentage of process colours. The quality of the blend is limited by the number of shades of a single colour that can be reproduced without visible 'banding'. Since this limit is determined by the PostScript maximum of 256 levels, banding may become more visible when the values of a single colour are very close (30 per cent–60 per cent, for example). However, blending two or more colours reduces the risk of banding.

Boolean Named after G. Boole, a 19th-century English mathematician, Boolean is used to describe a shorthand for logical computer operations, such as those that link values ('and', 'or', 'not', 'nor', etc., called 'Boolean operators'). For example, the search of a database could be refined using Boolean operators such as in 'book and recent or new but not published'. 'Boolean expressions' compare two values and come up with the result ('return') of either 'true' or 'false', which are each represented by 1 and 0. In 3D applications, Boolean describes the joining or removing of one shape from another.

Bounding Box A rectangular box, available in certain applications, which encloses an item so that it can be resized or moved. In 3D applications, the bounding box is parallel to the axes of the object.

Buffer An area of computer memory set aside for the storage or processing of data while it is in transit. The buffer can either be in RAM or on a hard disk – within your computer the buffer is called the 'cache'. Buffers are commonly used by output devices such as modems and printers, which are then able to process data more quickly, while at the same time freeing up your computer so that you can keep on working.

Bump map A bitmap image file, normally greyscale, that is most frequently used in 3D applications for modifying surfaces or for applying textures. The grey values in the image are assigned height values, with black representing the troughs and white the peaks. Bump maps are used in the form of digital elevation models (DEMs) to generate cartographic relief maps.

CAD (computer-aided design) Strictly speaking, any design carried out using a computer, but the term is generally used with reference to 3D design, such as product design or architecture, where a computer software application is used to construct and develop complex structures.

Camera A device in which light passes through a lens to record an image. The image can be recorded on to pre-sensitized film or paper, or by means of electronic sensors (CCDs) which digitally 'write' the image to a storage

device, such as a memory card or hard disk. In 3D the camera is virtual and is used to define the rendered viewpoint. 3D cameras tend to have controls that mimic their real-world counterparts, such as zoom and field of view, lens type, shutter speed, etc.

Camera moves A feature of 3D applications that allows you to perform typical film and video camera movements in animated sequences, such as 'pans', 'tilts', 'rolls', 'dolly shots' and 'tracking shots'.

Cartesian coordinates A geometry system employed in 3D applications that uses numbers to locate a point on a plane in relation to an origin where one or more points intersect.

Channel Any animatable parameter. Can also mean one of the components of a material (for example, Diffuse channel).

Child An object linked hierarchically to another object (its 'parent'). For example, if a 'child' box is placed within – or linked to– a 'parent' box, when the latter is moved, the child – and all its 'grandchildren'! – move with it, retaining their relative positions and orientation. This enables manipulation of complex structures, particularly in 3D applications.

Clipping plane In 3D applications, a plane beyond which an object is not visible. A view of the world has six clipping planes: top, bottom, left, right, front and back.

Collision detection The ability of a 3D program to calculate the proximity of objects and prevent them from intersecting.

Concave polygon A polygon whose shape is concave, for example, a star shape.

Convex polygon A polygon whose shape is convex, for example, a regular hexagon shape.

Coordinates Numerical values that define locations in 2D or 3D space.

Coplanar When points or polygons lie on the same plane.

Diffuse A material or surface property or channel. Diffuse shading is produced in the real world by subsurface scattering of light on an object. This process is simplified in 3D graphics but the results are very similar.

Digital Anything operated by, or created from, information or signals represented by binary digits, such as a digital recording. As distinct from analogue, in which information is represented by a physical variable (in a recording this may be via the grooves in a vinyl platter).

Displacement map Offsetting the points of an object using the brightness values in an image.

Drop-off The effect of a value decreasing as the distance from a reference point increases. In lights the intensity may be set to drop off, the further from the light you get.

Environment map In 3D applications, a 2D image (PICT or BMP, for example) that is projected onto the surface of a 3D object to simulate an environmental reflection.

Exploded view An illustration of an object displaying its component parts separately – as though it were exploded – but arranged in such a way as to indicate their relationship within the whole object when assembled

Extrapolate Creating new values for a parameter based on the values that have gone before.

Extrude The process of duplicating the cross-section of a 2D object, placing it in a 3D space at a distance from the original and creating a surface that joins the two together. For example, two circles that become a tube.

Face Another name for a single polygon on a mesh.

Fall-off In a 3D environment, the degree to which light or any parameter loses intensity away from its source. (See also Drop-off.)

Field In documents and dialog boxes, the term generally describing any self-contained area into which data are entered. In video a field is a subframe that contains either every odd or every even line of pixels in an image.

Fillet (**1**) A curved surface that is created between two adjoining or intersecting surfaces (usually NURBS).

Fillet (**2**) A curved segment that joins two lines.

Forward Kinematics Traditional animation is based on Forward Kinematics, where, for example, to make a character reach for an

object, first the upper arm is rotated, then the forearm and then the hand.

Frame (**1**) An individual still image extracted from an animation sequence.

Frame (**2**) The basic divisor of time in animation.

FPS 'Frames Per Second' The number of individual still images that are required to make each second of an animation or movie sequence.

Frame rate Same as frames per second. The common frame-rate for sequences used for computer display is 12–15 frames per second (fps), while in film it is 24fps, NTSC video 30fps and PAL video 25fps.

Fresnel factor In a 3D environment, the brightening of the edge of an object by increasing the intensity of reflection along the edge, giving a more realistic visual effect.

Function curve A graphical representation of how an animated value changes over time. The function curve is a simple line in a graph that displays the value on one axis and time on the other.

Geometry What 3D objects are made out of, or rather described by. Geometry types include polygons, NURBS and Bézier patches.

Gimbal lock In 3D applications, a situation in which an object cannot be rotated around one or more axes.

Glow A material parameter used to create external glows on objects. The glow usually extends beyond the object surface by a defined amount.

Gouraud shading A means by which 3D programs 'fill in' the surface polygons of objects so that they look smooth and solid. The shading is derived by interpolating the surface vectors (called Normals) at each vertex to produce a graduated or smooth shaded look, as opposed to the faceted appearance that would result if no interpolation was done.

Greyscale The rendering of an image in a range of greys from white to black. In a digital image and on a monitor this usually means that an image is rendered with eight bits assigned to each pixel, giving a maximum of

185

256 levels of grey. Monochrome monitors (used increasingly rarely nowadays) can only display black pixels – in which case, greys are achieved by varying the number and positioning of black pixels using the technique called dithering.

Grid In some applications, a user-definable background pattern of equidistant vertical and horizontal lines to which elements such as guides, rules, type, boxes, etc., can be locked, or 'snapped', thus providing greater positional accuracy.

Heading Local y-axis rotation. Part of the HPB rotation system (Heading Pitch Bank).

Height map An image used to displace or deform geometry. (See also Displacement.)

Hidden Surface Removal A rendering method, usually wireframe, that prevents surfaces that cannot be seen from the given view from being drawn.

Hierarchy When objects are linked together to provide a priority system for certain operations. For example, a simple hierarchy might go upper leg > lower leg > foot. Moving the upper leg moves the lower leg and the foot by the same amount. If the foot is moved, the other two are not affected.

Interpolation A computer calculation used to estimate unknown values that fall between known ones. One use of this process is to redefine pixels in bitmapped images after they have been modified in some way – for instance, when an image is resized (called 'resampling') or rotated, or if colour corrections have been made. In such cases the program makes estimates from the known values of other pixels lying in the same or similar ranges. Interpolation is also used by some scanning and image-manipulation software to enhance the resolution of images that have been scanned at low resolution. Inserting animation values between two keyframes of a sequence are also interpolations.

Inverse Kinematics Or IK for short. When animating hierarchical models, IK can be applied so that moving the lowest object in the hierarchy has an effect on all the objects further up. This is the inverse of how Forward Kinematics works.

Joint A special object type that does not render and can be used as the building blocks of skeletons, which in turn can be used to animate 3D models.

Kinematics Animated motion.

Lathe In 3D applications, the technique of creating a 3D object by rotating a 2D profile around an axis – just like carving a piece of wood on a real lathe.

Layer The grouping of objects into partitions so that they can easily be hidden or shown en masse.

Light The stuff that lets us see our 3D objects when we render our scene.

Magnet A tool that lets you pull and push the point on an object with a smooth drop-off effect.

Map Any image applied to a texture channel.

Mapping The process of applying textures to an object by defining a suitable projection method.

Material The aggregate of all surface attributes for an object.

Memory The recall of digital data on a computer. Typically, this refers to either 'dynamic RAM', the volatile 'random access' memory that is emptied when a computer is switched off (data need to be stored on media such as a hard disk for future renewal), or ROM, the stable 'read only' memory that contains unchanging data, for example the basic start-up and initialization functions of some computers, such as Macintosh. As an analogy, think of your own memory – when you die, everything in your head is lost unless you write it down, thus 'saving' it for posterity. 'Memory' is often erroneously used to describe 'storage', probably because both are measured in megabytes.

Mesh Vertices that are linked together to form Polygon or NURBS (or other) surfaces.

Motion channel An animation parameter that controls how an object moves (for example, rotation x, y, z and translation x, y, z are all Motion channels).

Move A tool used to translate 3D objects or components.

Multi-pass rendering The process whereby a single scene is rendered in multiple passes, each pass producing an image (or movie or image sequence) containing a specific portion of the scene but not all of it (for example, one part of a multi-pass render may contain just the reflections in the scene, or just the specular highlights. It may also contain single objects or effects).

Normal In 3D objects, the direction that is perpendicular to the surface of the polygon to which it relates.

Null A special object that has no geometry. Essentially it is an 'empty' set of object axes. Nulls, however, are extremely useful, because objects can be linked to them, facilitating all manner of animation tricks and work-arounds. A camera may be linked to a hierarchy of Nulls for animation. The Nulls can be animated instead of the camera preventing Gimbal lock.

NURBS Non-Uniform Rational B-Spline. A special curve (and when linked together, a surface) in 3D programs that is defined by a mathematical equation. Requires fewer points than polygons to achieve smooth flowing lines and surfaces.

Open (curve) A curve that does not form a closed loop.

Parallax The apparent movement of two objects relative to each other when viewed from different positions.

Parent In a hierarchy, the parent is the object to which a given object is linked below.

Phong shading Phong shading is a superior method of shading surfaces that computes the shading of every pixel by interpolating surface Normals.

Pitch The rotation around the x-axis as used in the HPB rotation system.

Pixel Acronym of picture element. The smallest component of a digitally generated image, such as a single dot of light on a computer monitor. In its simplest form, one pixel corresponds to a single bit: 0 = off, or white, and 1 = on, or black. In colour or greyscale images or monitors, one pixel may correspond to several bits: an 8-bit pixel, for example, can

be displayed in any of 256 colours (the total number of different configurations that can be achieved by eight 0s and 1s).

Plug-in Software, usually developed by a third party, which extends the capabilities of a particular program. Plug-ins are common in image-editing and page-layout applications for such things as special effect filters. Plug-ins are also common in Web browsers for such things as playing movies and audio, although these often come as complete applications ('helper applications'), which can be used with a number of browsers rather than any specific one.

Polygon Composed of points joined by edges, polygons are the basic building blocks of 3D objects. They are not the only things that 3D objects can be constructed from, but when they are rendered, 99 per cent of the time polygons are used.

Primitive The basic geometric element from which a complex object is built.

Quad A four-point polygon.

QuickTime Apple's software program and system extension, which enables computers running either Windows or the Mac OS to play movie and sound files, particularly over the Internet and in multi-media applications, providing cut, copy and paste features for moving images and automatic compression and decompression of image files.

RAM (**Random Access Memory**) A feature provided by some operating systems or utility software whereby a part of memory (RAM) can be temporarily 'tricked' into thinking that that particular part is a disk drive. Because the process of retrieving data from RAM is so much faster than from disk, operations performed by items – such as applications or documents – stored in a RAM 'disk' will speed up. This 'disk' is erased when you switch your computer off.

Raycasting A no-bounce raytracing technique. (See Raytracing.)

Raytracing A rendering algorithm that simulates the physical and optical properties of light rays as they reflect off a 3D model, producing realistic shadows and reflections.

Real-time The actual time in which things happen; on your computer, therefore, an event that corresponds to reality. For example, at its simplest, a character appearing on screen at the moment you type it is said to be real-time, as is a video sequence that plays back as it is being filmed. Also called 'interactive mode'.

Reflection The image of an environment or surrounding objects in the surface of a reflective object.

Refraction Light that is bent, typically when passing through one medium to another, such as air to water.

Rendering The process of creating a 2D image from 3D geometry to which lighting effects and surface textures have been applied.

RGB Red, green, blue. The primary colours of the 'additive' colour model – used in video technology (including computer monitors) and for graphics (for the Web and multi-media, for example) that will not ultimately be printed by the four-colour (CMYK) process method.

Roll In a 3D environment, the rotation of an object or camera around the z-axis.

Rotate A 3D transformation that turns an object about one or more axes.

Round To bevel an edge or vertex.

Scale A 3D transformation that shrinks or enlarges an object about one or more axes.

Shading The process of filling in the polygons of a 3D model with respect to viewing angle and lighting conditions.

Skin In 3D applications, a surface stretched over a series of 'ribs', such as an aircraft wing.

Snapping In many applications, a facility which automatically guides the positioning of items along invisible grid lines, objects, components etc., aiding design and layout.

Specular map In 3D applications, a texture map – such as those created by noise filters – that is used instead of specular colour to control highlights.

Spline The digital representation of a curved line that is defined by three or more control points.

Stitching A technique in NURBS modelling whereby two or more surfaces are joined along their boundaries.

Storyboard A sequence of drawings used to lay out the action and camera angles in a film or animation.

Surface In 3D applications, the matrix of control points and line end points underlying a mapped texture or colour.

Surface geometry In 3D applications, the geometry that underlies a surface, becoming visible when the surface is simplified.

Sweep The process of creating a 3D object by moving a profile along a path.

Texture The surface definition of an object.

Texture filtering A method for improving (or reducing) the quality of textures for use in 3D programs.

Tiling An image repeated two or more times to create a background. A background image, smaller than the size of the screen (which is, in turn, arbitrary), is automatically tiled to fill the screen.

Transformation tool In some applications, the name given to tools that change the location or appearance of an item, such as scale, rotate and move.

Triangle The simplest type of polygon is a triangle, which is made from three connected vertices.

UV coordinates In a 3D environment, a system of rectangular 2D coordinates used to apply a texture map to a 3D surface.

Vertex Another name for a point (polygons) or control point (NURBS).

View A window in a 3D program depicting the 3D scene from a given vantage.

Wireframe A skeletal view, or a computer-generated 3D object before the surface rendering has been applied.

Z-Buffer A 3D renderer that solves the problem of rendering two pixels in the same place (one in front of the other) by calculating and storing the distance of each pixel from the camera (the 'z-distance'), then rendering the nearest pixel last.

187

2D images 32–33, 131
3D, definition 184
3D Me 161
3D Studio Max 20, 158

A

A Bug's Life 29
Abbott, Michael D. 181
ACIS geometry kernel 19, 104
Adobe 158, 159
akima curve 49
Alias|Wavefront 14, 87
Alpha channel 184
Ambient shading 72–73, 184
Amorphium 26
animation
 see also character animation
 definition 184
 frames per second 129, 130, 132
 GIF 168
 guidelines 142–45
 instruction manuals 164
 keyframe 29, 132–35
 motion blur 129, 130–31
 principles 128–29
 software 22, 24, 25, 28, 29
 storyboard 114
anti-aliasing 19, 184
API (Application Programming Interface) 66, 166, 184
architectural visualization 21, 115–17, 172–73
area light 184
art
 creating 174–75
 historical painters 11
 software 14
 on Web 164
ART, RenderDrive 86
Atmospheres 158, 159
AutoDesSys, Form*Z 19
axis 184

B

B-spline curve 49, *184*
bank 184

bevel 184
Bézier
 character animation 62
 curve 49, 54–55, 56, 134, 184
 surface 54, 55
bitmap 184
blend 184
Blinn shading 70, 71
Blue Moon Rendering Tools (BMRT) 28, 29
Boolean 184
 intersections 112
 modelling 110–13
 subtraction 104, 106, 110, 120
 Union 107
Bounding Box 66, 67, 184
breakdown keys 135
Bryce 6, 23, 158
buffer 184
buildings 21, 115–17, 172–73
bump map 77, 78–79, 82–83, 179, 184

C

CAD (Computer-Aided Design) 28, 34, 62, 102, 184
Caligari 22
CAM (Computer Assisted Manufacturing) 62, 102
camera 184–85
camera moves 142–45, 185
Canaletto 11
Cartesian coordinates 36, 38, 39, 185
caustics 19, 21
channel 185
character animations
 geometry choice 62, 63
 guidelines 144–45
 jointed hierarchies 136–37
 single-skin models 138–41
 software 14–15, 16, 18, 19, 20, 24, 26, 28
 spline patches 53
 subdivision surfaces 63
child 185
Cinema 4D XL 18–19, 108, 158
clipping plane 185

cloth 14, 125
collision detection *185*
colour 68–69, 70, 72–73, 76, 77
composition 10–11, 71
Computer Arts 175, 176
computer graphics 32–35
concave polygon 185
cone 45
construction history 28
control points 56, 96, 102
control vertices (CV) 56, 57
convex polygon *185*
Cook-Thorrance shading 70
coordinates 36, 185
coplanar 185
creases 53, 61
Cryonetworks 162–63
Cryopolis 162
cube 44
cubic curve 49
Cubic interpolation 134
Cult3D 160–1
Curious Labs 24
curves
 Bézier 54–55, 56
 creating 48–9
 function 134–5
 modifying 134–5
 NURBS 56–57
 resolution 50–1
 spline patches 52–53
cutting tools 102, 105, 107, 110
CV see control vertices
cyber gloves 35–36
Cycore Computers 160
cylinder 45, 104, 106, 118–125

D

Debevec, Paul 12–13
deforming modifiers 26
Degree 56
depth sorting 90, 91
design skills 6–7
detail 115, 118–25, 178
Diffuse 185
 channels 80, 81
 reflections 74
 shading 72

digital 185
Direct3D 22, 87
DirectX 66
Discreet 20
Disney 32
displacement map 83, 185
displacing brushes 26
display rendering 86, 87, 88
distant objects 115
drop-off 185
dynamic range 12–13
dynamics simulation 14

E

ease-in, ease-out curve 133, 134
economical modelling 114–17
edges 105, 126–27
ElectricImage 19, 26, 85, 104, 174
environment generator 23
environment map 84–85, 177, 185
exploded view 164, 174, 185
extrapolate 185
extruding 46, 52, 59, 185

F

face 185
fall-off 185
Fiat Lux 12
field 185
fillet 185
FilmBox 28
films
 3D animated 15, 32, 86, 131
 animation techniques 128–45
 camera movement 142–43
 effects software 14, 15, 16, 18, 19
 industry standards 129
final-quality rendering 87
fine art, software 14
Flash 26, 154, 156, 168
Fog 162
Form*Z 19
formulae 101
Forward Kinematics (FK) 136, 185
frame 185
frames per second (FPS) 129, 130, 132, 185

Fresnel shaders 125, 185
function curves 134–5, 185
fur simulation 14

G

Gallerie Abominate 7
galleries, virtual 164
games
 modelling 178–79
 polygon geometry 63
 rendering 87
 SCOL 162–63
 software 14, 16, 20
geometry *185*
 choosing 52–53
 surface 187
Gestel 28
GIF animation 168
Gimbal lock 185
Giotto 10
glass 65, 86, 89, 177
global illumination 19
glossary 184–87
glow 185
goggles, 3D 36
Gouraud shading 68, 185
Green, William 174
greyscale image 77, 78, 83, 90,
 185–86
grid 186
Gritz, Larry 29

H

Hanson, Eric 176
Hash Animation Master 26
heading 186
Heidi 66
height map 186
helixes 49
Hidden Surface Removal 186
hierarchy 186
high-dynamic-range imagery
 12–13
highlights 70, 72, 74, 84, 126, 175
Holman, Geoff 178, 179
holograms 33
hull 56, 96
human eye 12, 33, 128, 130

human face 13, 161
human figures 24
Hypercosm 164–65

I

illumination 72–3, 75, 175
illustration 174–75
image
 display box 33
 maps 76–9, 80
 uses 32, 34
 views 38–39
industrial design 34, 102
instruction manuals 164, 174
interactive applications
 computer graphics 33
 polygon geometry 63, 178
 rendering 86, 87, 88
 on websites 156, 162–63, 166
interpolation 133, 134–35, 186
Inverse Kinematics (IK) 136, 186
Isoparms display 66

J

Java 3D 166–67
joint 186
Jurassic Park 15, 131

K

Kaydara FilmBox 28
keyframe animation 29, 132–35
kinematics 186
Knife tool 102, 105, 107

L

Ladopoulos, Dimitris 180
Lambert shading 70
landscapes 6, 23, 85
lathing 47, 52, 186
layer 186
learning to see 10–11, 71
Leonardo da Vinci 10
light
 architecture 172
 bounced 72, 74
 definition 186
 high-dynamic-range imagery 12
 highlights 70, 72, 74, 84, 126, 175

historical painters 11
 natural, simulation 19, 21
 photorealism 176
 radiosity 92
 raytracing 88
 reflected 74–75, 88, 92.
 shading 64, 68, 71, 72–73
Lightscape 21
Lightwave 3D 16–17, 52, 134, 177
limbs 136–37, 138, 141
linear curves 49
lip syncing 24
Local axes 42, 136
local centre 42
lofting 47, 52
low-level editing 44
luminance maps 175
luminosity 80, 81

M

Macromedia 156
MacUser magazine 174
Maestri, George 136
Magnet tool 51, 123, 186
map/mapping 186
material 186
 channel intensity 80–81
matt surfaces, shading 71, 72
Maxon 18, 108
Maya 14, 87, 98, 135, 141
McNeel, Robert 22
medical uses 32
memory 186, 187
Mental Image 16, 21
Mental Ray 16, 20, 21
MetaCreations 24, 158
metallic objects
 illustration 175, 177
 image maps 76
 reflections 84
 shading 71
MetaNURBS technology 17
Metastream technology 158
Michaelangelo 10
modelling
 Boolean 110–13
 detail 115, 118–25, 178
 economical 114–17

examples 96
high-level tools 46–47
NURBS 57
primitives 44–45, 108–9
product visualization 180–81
prototypes 34, 35
real-time 3D 178–79
skeleton 138–40
software 16–17, 18, 19, 22, 27,
28
Solids 102–7
spline 52–53
subdivision surfaces 58–61
motion
 blur 129, 130–31
 capture 28, 129
 channel 186
 final-quality rendering 87
 keyframe interpolation 132–33
 testing 66
move 186
moving objects 38, 43
multi-pass rendering 19, 186

N

nodes 14
non-streaming data 154, 156
Normals *see* Surface Normals
null 186
NURBS (Non-Uniform Rational
 B-Spline) 186
 curve 49, 56–57
 MetaNURBS 17
 modelling 96, 97
 Primitives 57
 software 22, 25, 28
 surfaces 57, 102, 146–49
 tessellation 98–99
 UberNURBS 19
 uses 62

O

objects
 creating 40–1
 illumination 72–73
 modelling 44, 57, 58
 parametric 100–1
 real 34–35

Solid 102–3
surface finish 76–79
transformation 42–43
viewpoint 38–39, 180, 181
occlusion 90
open curve 186
OpenGL 22, 26, 64, 66, 87, 141
Oren-Nayer shading 70, 71
orientation of image 39, 41, 180
orthogonal view 38–39
Overcaster 177

P

190

parallax effects 38, 186
parametric objects 66, 100–1, 119–20
parent 186
patch modelling 26, 52–53
persistence of vision 128
perspective
historical painters 10–11
view of images 38
phi phenomenon 128
Phong shading 70, 71, 186
photography
camera techniques 142–45
environment maps 85
high-dynamic-range imagery 12–13
image maps 76, 79
ImageModeler 27
Photon mapping 92
photorealism 87, 88, 176–77
Photorealistic RenderMan (PRMan) 15, 28, 29, 90
Photoshop 77, 85, 121, 158
pipes 49
piston, Solid modelling 104–7
pitch 186
Pivot Point 42
Pixar animation studios 29, 32, 86
pixel 186
Pixels 3D 25
plane 44
plastic objects, shading 71
plug-ins 187
for software 17, 19, 20, 177
on Web 154, 158, 160, 166

point by point modelling 44
Point Cloud 66, 67
point editing 44
point of view (POV) shots 143
polygon 187
creating 40–41
modelling 44, 59, 60, 96, 178
planar 46
resolution 50–51, 58–59
shading 68
smooth surfaces 50, 52
tessellation 98
tools 46–47, 51
UV coordinates 150–51
Poser 24, 158
POVray (Persistence Of Vision) 22
Primitive objects 44–45, 57, 101, 104, 108–9, 118, 187
product visualization
Hypercosm 164
modelling 180–81
prototype production 34–35
software 14, 28
Solids 102
profiles, lofting tool 47
projection mapping 146, 150
prototypes 34, 35, 180
pyramid, primitive 45

Q

quad 187
QuickDraw 3D 66, 154
QuickTime 3D 85, 187

R

radiosity
buildings 172
principles 92–93
software tool 19, 21, 22, 26, 28, 29
RAM (Random Access Memory) 187
raycasting 187
raytracing 187
principles 88–89
reflections 75, 84, 88, 90

software 7, 19, 21, 22, 25, 26, 28, 29
real objects 34–35
real-time 187
animation 28
modelling 178–79
output 33, 87, 164
RealVIZ Image Modeler 27
reflection mask 121
reflections 187
channel intensity 80
environment mapping 84–85
metallic surfaces 177
raytracing 88
scanline rendering 90
shading 65, 72
specular 74–75
refraction 89, 90, 187
RenderDrive 86
rendering 187
see also radiosity; raytracing
APIs 66, 166
categories 86–87
display 86, 87
environment maps 85
final-quality 87
interactive 86
photo-real 87, 88, 176
pre-rendered scenes 168
process 64
scanline 90–91
software 15, 16, 19, 20, 21, 22, 25, 26, 28, 29
resolution 50–51, 58–59, 99, 100, 122
REYES (Renders Everything You Ever Saw) 15
RGB (red, green, blue) 187
Rhino 22
RIB interface 29
roll 187
rotating objects 43, 187
Rounding tool 105, 107, 109, 119, 187

S

scaling 43, 108, 120, 187
scanline rendering 90–91
SCOL 162–63
sculpting 123
SGI Inc. 66
Shaders 75, 125
shading 187
Ambient 72–73, 184
Blinn 70, 71
colour and light 68–69, 71, 72–73
Cook-Thorrance 70
Diffuse 72
edges 126
flat 68, 168
Gouraud 68, 185
Lambert 70
Oren-Nayer 70, 71
Phong 70, 71, 186
procedural 124
process 64–71
reflections 84
smooth 64
Specular 72, 75, 78
Surface Normal 41
texture 65, 76, 78, 82, 124–25
wireframe view 65, 66
shadow
Ambient shading 72–73
edges 126
photorealism 176, 177
radiosity 93
raytracing 88
scanline rendering 90
Sherstobitoff, Paul 174
shiny surfaces 65, 72
shopping 166–67
Shout3D 167
single-skin characters 17, 138–41
skeleton 138–40
Skin tool 47, 187
smooth surfaces 50, 52, 58–59, 70, 96
snooker cue 118–25
Softimage 3D 16, 21

Softimage XSI 16, 21, 151
software
 3D Studio Max 20, 158
 Amorphium 26
 Blue Moon Rendering Tools 28, 29
 Bryce 6, 23, 158
 Cinema 4D XL 18–19, 108, 158
 ElectricImage 19, 26, 85, 104, 174
 Hash Animation Master 26
 Kaydara FilmBox 28
 Lightscape 21
 Lightwave 3D 16–17, 134
 Maya 14, 87, 98, 135, 141
 Photorealistic RenderMan 15, 28, 90
 Pixels 3D 25
 Poser 24, 158
 POVray 22
 RealVIZ Image Modeler 27
 Rhino 22
 Softimage 3D 16
 Softimage XSI 16, 151
 SolidThinking 28
 Strata 3D 25
 Tempest 25
 Truespace 22
 updates importance 18
Solid geometry
 creating a piston 104–7
 principles 102–3
 uses 62, 102
SolidThinking 28
space, three-dimensional 36–37
Spatial Technology 19, 104
specular
 intensity 80, 81
 map 187
 reflections 74–75
 shading 72, 75, 78
sphere
 Boolean modelling 110
 bump maps 82
 creating 41
 image maps 76–81
 NURBS 57
 primitive 45

reflections 75
resolution 50–51
size 38, 39
spline 49, 187
 Bézier 54–55, 184
 curves 49, 52
 patches 52–53
St Peter's Basilica, Rome 12
stereolithography 34
stitching 187
storyboard 114, 187
Strata 3D 25
streaming technology 154, 158, 160, 167
subdivision surfaces 17, 18, 19, 28, 58–61, 63
Sun 166
surface 187
 contours 66
 finish 65, 72, 76–79, 178
 smooth 50, 52, 58–59, 70, 96
 tessellation 98
Surface Normal
 definition 41, 186
 extrusion tools 46
 shading 68, 69, 70
 texture 78, 83
Sweeping 49, 52, 187
symmetrical objects 47

T

table 108–9
tangent handles 54, 134
TCB controls (Tension, Continuity and Bias) 134
Tempest 25
tessellation 65, 98–99
tetrahedron 40
texture 187
 bump maps 78, 82, 179
 detail 115, 178
 displacement maps 83
 image maps 76–79
 map 121, 178, 179
 multiple 124
 polygon objects 150–51
 product visualization 180
 shading 65, 75

UV mapping 146–51
tools
 cutting 102, 105, 107, 110
 high-level 46–47
 Magnet 51, 123, 186
 multiple surface joining 62
 Rounding 105, 107, 109, 119
Top view 39
torus 45, 106, 110
Toy Story 32, 86, 141, 167
training aids 164
transformation 42–43, 187
transparency 80, 89
triangle 187
Truespace 22
tubes 49
tutorials, online 164
tweening 132
two dimensional images 32–33, 131

U

UberNURBS 19
Up axis 39
UV coordinates 57, 146, 150, 187
UV texture mapping 146–49

V

Van Eyck 11
Vermeer 11
vertex 187
video production 17, 129
view of images 38–39, 187
Viewpoint 24, 158–59
Vila, Cristobal 176, 177
VRML (Virtual Reality Markup Language) 154, 156–57

W

Web
 3D uses 154, 161, 162, 164, 167, 168
 Cult3D 160–61
 data compression 154, 156, 166, 168
 Hypercosm 164–65
 Java 3D 166–67
 pre-rendered scenes 168

SCOL 162–63
Viewpoint 158–59
VRML 154, 156–57
websites 6, 13, 162, 163, 166
Web|3D Consortium 156
wireframe view 65, 66, 187
wood 76–77, 78
World coordinates 42, 43

X

X3D 156
x axis 36

Y

y axis 36, 39

Z

z axis 36, 39
Z-Buffer sorting algorithm 90, 187
zoetrope 128

ACKNOWLEDGEMENTS

Picture credits

AKG, LONDON
10T Santa Maria della Grazie Refectory, Milan; 11T AKG, LONDON/Erich Lessing.

BRIDGEMAN ART LIBRARY, LONDON
10M Scrovegni (Arena) Chapel, Padua; 11B Birmingham Museum and Art Gallery; 11R Metropolitan Museum of Art, New York.

CORBIS
32–33 Toshiyuki Aizanwa/Reuters NewMedia Inc.; 87B Paul A. Souders; 128 Hulton-Deutsch Coll.; 129 Duomo.

THE KOBAL COLLECTION, LONDON
32B Disney/Pixar © Disney Enterprises Inc.; 33 Paramount; 36–37 and 37 Ben Jade/Large-Pringle/Allied Vision; 87B © Warner Bros.

THE SCIENCE PHOTO LIBRARY: 36–37T NASA.